IMAGES of America
STONE ARCHITECTURE IN SANTA BARBARA

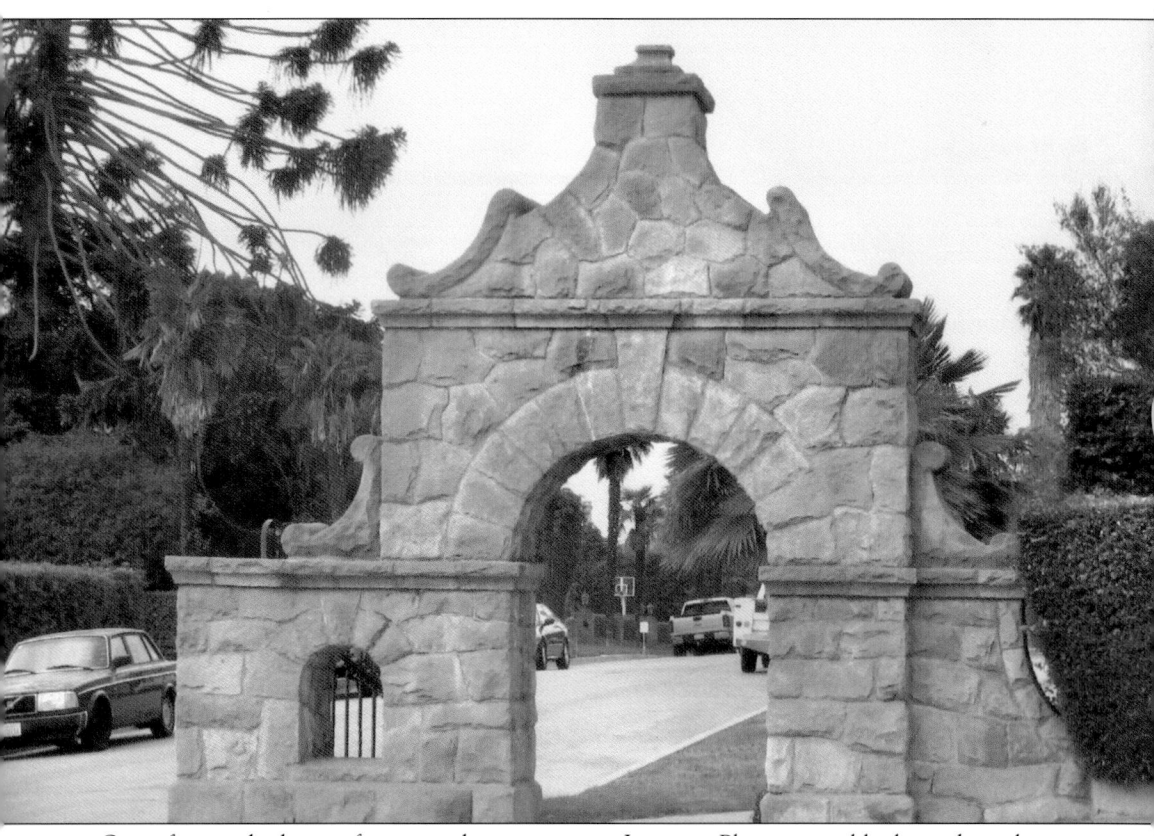

One of a matched pair of gates at the entrance to Junipero Plaza, a one-block residential street just below Mission Santa Barbara, this stunning piece of stonework by an unknown author has been a local landmark ever since it was built. As a showpiece for classic stone construction, these gates are unsurpassed. (The Santa Barbara Conservancy.)

ON THE COVER: John Arroqui's hard-working crew of stonemasons takes time out from a massive wall project to pose for a photographer. (The Santa Barbara Historical Museum.)

IMAGES *of America*
STONE ARCHITECTURE IN SANTA BARBARA

Santa Barbara Conservancy

Copyright © 2009 by Santa Barbara Conservancy
ISBN 978-0-7385-6968-0

Published by Arcadia Publishing
Charleston, South Carolina

Printed in the United States of America

Library of Congress Control Number: 2008938272

For all general information contact Arcadia Publishing at:
Telephone 843-853-2070
Fax 843-853-0044
E-mail sales@arcadiapublishing.com
For customer service and orders:
Toll-Free 1-888-313-2665

Visit us on the Internet at www.arcadiapublishing.com

This volume is dedicated to the memory of John Pitman, F.A.I.A., our inspiration and mentor. No one cared more for his community or worked harder on its behalf. (Pitman family.)

Contents

Acknowledgments		6
Introduction		7
1.	Spaces: Public and Private	9
2.	Homes and Gardens: The Personal Side of Stone	39
3.	Infrastructure: Bridges and Walls	71
4.	Oddments: Interesting Uses of Stone	109
Bibliography		126
The Santa Barbara Conservancy		127

Acknowledgments

The Santa Barbara Conservancy wishes to express its deepest thanks to those institutions and individuals whose contributions made this volume possible: Santa Barbara Historical Museum executive director David Bisol, who offered us free access to his institution, and most particularly to museum librarian Michael Redmon. Mike's intimate knowledge, not only of Santa Barbara history but also of the nooks and crannies of his institution's holdings, certainly made our work easier and saved us from omissions and errors. We offer our thanks to the Montecito History Committee and its irrepressible Maria Herold. Maria's incomparable knowledge of Montecito and its environs and her love for its stoneworks combined with an enthusiasm for the subject that nearly overwhelmed us at the beginning but made our work with her a joy.

Our gratitude extends to the unnamed surveyors of the walls of the Riviera who opened our eyes to the vast treasure of stonework that exists in the region and to the various members of the Santa Barbara Conservancy for their research and explication of various examples of stonework. It also extends to Oswald Da Ros, himself a second-generation mason, who gave us insight into the art of stonemasonry.

We should also extend a posthumous note of gratitude to Walker A. Tompkins, noted local historian and newspaper correspondent, and Stella Haverland Rouse, columnist for the *Santa Barbara News-Press*, both of whom kept stories of the past alive and chronicled the lives, and occasional deaths, of Santa Barbara's temples of stone. Thanks as well to Patricia Cleek and Elane Griscom, two solid researchers whose writings memorialize stoneworks and their makers, and to Hattie Beresford, who, in the tradition of Tompkins and Rouse, keeps the past alive for the present generation. Without the meticulous work of David Myrick, whose marvelous two-volume work about Montecito and Santa Barbara became our bible, this book would not have been possible. Errors of fact and judgment are, of course, ours alone.

Photographs used in this volume, unless otherwise noted, come from three main sources: the Santa Barbara Historical Museum (SBHM), Montecito History Committee (MHC), and the Santa Barbara Conservancy (CONS).

Introduction

The use of stone as a building material is almost as old as humanity itself. Indeed one can almost imagine our far distant ancestors piling rocks at the mouths of caves to provide security, keep out unwanted visitors, and even maintain an equitable internal climate. While man no doubt continued to use stone, the problem of utilizing it as a building material was, of course, its great weight in relation to man's relatively puny strength. But over the ensuing millennia, man the manipulator learned not only how to make tools but to create specialized ones that increased his strength—levers abetted by the development of the fulcrum, pulleys, wheels and axles, cranks, gears, screws, jacks, and the like—which helped him move stones as well as perform other tasks. At the same time, he was beginning to comprehend the geology of rocks, to understand their internal makeup, to assess varying hardness, to recognize grain patterns, and particularly to understand which stones were susceptible to easy modification so that they might be made more useful. Gradually man developed a kit of tools—chisels, mallets, wedges, saws, drills, and other specific instruments—to work stone and to square off round stones so that they might more safely be piled up to create walls and other structures. He further learned to quarry stone from major deposits both above and below ground. Ultimately, man learned that he could express his sense of beauty through stone, either by carving it into exquisite shapes or by erecting magnificent architectural structures.

Although the builders of the great cathedrals of Europe might argue, perhaps the epitome of stonemasonry occurred in ancient Greece with the erection of the Parthenon. This incredible 2,500-year-old structure, now in the process of being restored to its original grandeur, was made possible by the concurrence of an abundance of raw materials close by, a large cadre of superior stonemasons (enough to complete the project over a period of eight or nine years), and unlimited financing on the part of the government of Athens. As the summation of the stoneworking skills learned by man to that point, the Parthenon has never been surpassed. The stonework exhibited there was so exacting—often the line between fitted stones is too fine to be seen by the naked eye and sometimes even with a magnifying glass—that modern restoration experts simply throw up their hands in despair and just admit that those ancient Greek masons were better than we are. Or is it possible that those ancient Greeks, with their specialized knowledge of metallurgy, managed to produce, in the tradition of Damascus steel or the blades of Samurai swords of early Japan, finer, more effective tools than we can? In any case, modern reconstructors find themselves scratching their heads as they try to replicate what was done by those master masons two and a half millennia ago. How did they work such a subtle entasis into those massive pillars so as to trick the eye into seeing them as perfectly straight? How did they manage such wonderfully balanced proportions? What enabled them to carve the fluting in the columns with such precision? These and a host of other questions still remain, even in the face of our modern knowledge. Those master masons of ancient Greece demonstrated to the world, in what the 19th century French engineer and architectural historian Auguste Choisy called "the supreme effort

of genius in search of beauty," the kind of magnificence as well as utility that could be achieved through the use of stone.

Those early Greeks also developed standard methods for building large stone projects. For the Parthenon, they quarried stone some 10 miles away, rough-shaped the blocks at the quarry, carted them to the Parthenon's hill, and somehow lifted them (some of the individual blocks weighed over 10 tons) to the summit, where the blocks were finished to architectural specifications and set into place. Through it all, the architects and masons apparently had the freedom to innovate, solve problems as they occurred, and continually reach for perfection, something that succeeding stoneworkers turned into tradition over time. Greek methods and some of their skills were adapted by the later Romans and eventually passed down to the cathedral builders of Europe, creating an intellectual approach and a set of skills that have remained the basis of stonemasonry to the present. Interestingly, masons coming from outside the Greek-Western tradition exhibit the same skills and attitudes, indicating that stonemasonry is a universal art form.

While it would be folly to compare the stonework of Santa Barbara to that of the Parthenon, some important parallels do appear, and certainly, the search for beauty and perfection is apparent in the stonework presented here. Building with stone requires a commitment to permanence and, in the years between about 1875 and 1940, when Santa Barbara was quickly evolving from a small, dusty backwater into a vibrant, growing city, that commitment occurred. That period witnessed an extraordinary explosion of stone construction made possible by the fortuitous conjunction of factors: abundant raw materials in the form of an almost endless supply of a variety of sandstones, a growing cadre of expert artisans, and almost unlimited financing by a number of private citizens. This period provided an atmosphere conducive to the building of public and private spaces of all kinds, bridges, walls, gardens, and an assortment of other stoneworks and encouraged some exceptional expressions of the mason's art. Many of these fabrications remain, a testimony to the skill and taste of their creators, and we share them here with you. New ones are appearing all the time as stonemasonry continues to evolve, even as the faces of the masons change.

Beginning in the 1870s, the first group of masons to work in Santa Barbara came from a variety of national origins—England, Scotland, the United States, Germany, France, Italy, Mexico, and others. The next generation consisted primarily of Italians, particularly from the Lake Como region, hard against the Swiss border. As they passed and a second generation of Italian-Americans approached retirement, an influx of skilled stonemasons from Mexico continued to add to the varieties of stonework in Santa Barbara. Each group of stone builders has added its distinctive touch to the tradition of stonework in the region and contributed its own elements to the particular ambience that helps make Santa Barbara the special place it is. We hope you enjoy this brief look at the stone architecture in Santa Barbara.

One

SPACES

PUBLIC AND PRIVATE

The glories of stone architecture have always been most apparent in large buildings. Carved stone is not only structurally strong and generally beautiful in its own right, but when combined with excellence in design, it has continually impressed mankind for thousands of years. Those who aspired to otherworldly futures built extravagant monuments in stone to their gods; various rulers of nations or other political organisms tended to build stone testimonials to themselves, while those of more mundane aims were inclined toward utilizing stone in their constructions to symbolize strength, security, and sensibility.

In Santa Barbara, the same notions played out. In the latter half of the 19th century, individuals and organizations foresaw a limitless future for the then dull and backward village by the sea and invested themselves in the creation of that future. The various entities that participated in the elevation of Santa Barbara into a thriving small city utilized stone to indicate the permanency of their commitment to stay and prosper. Religious denominations built stone edifices to honor their gods and house their congregations. Office buildings and particularly banks incorporated stone into their public presences. As the city began to progress, a number of other institutions tended to follow the lead in stone construction as a means of indicating a commitment to permanence. Schools, hotels, government buildings, and even a local cemetery utilized Santa Barbara's most abundant resource to mark their occupancy of a permanent spot in the city. Within a very few years, Santa Barbara had about it an aura of success, indicated in part by the amount of stone construction in the city.

Presented here is a sampling of spaces, public and private, old and more modern, some now gone and some still functioning, but all exhibiting the many faces of stone architecture in Santa Barbara.

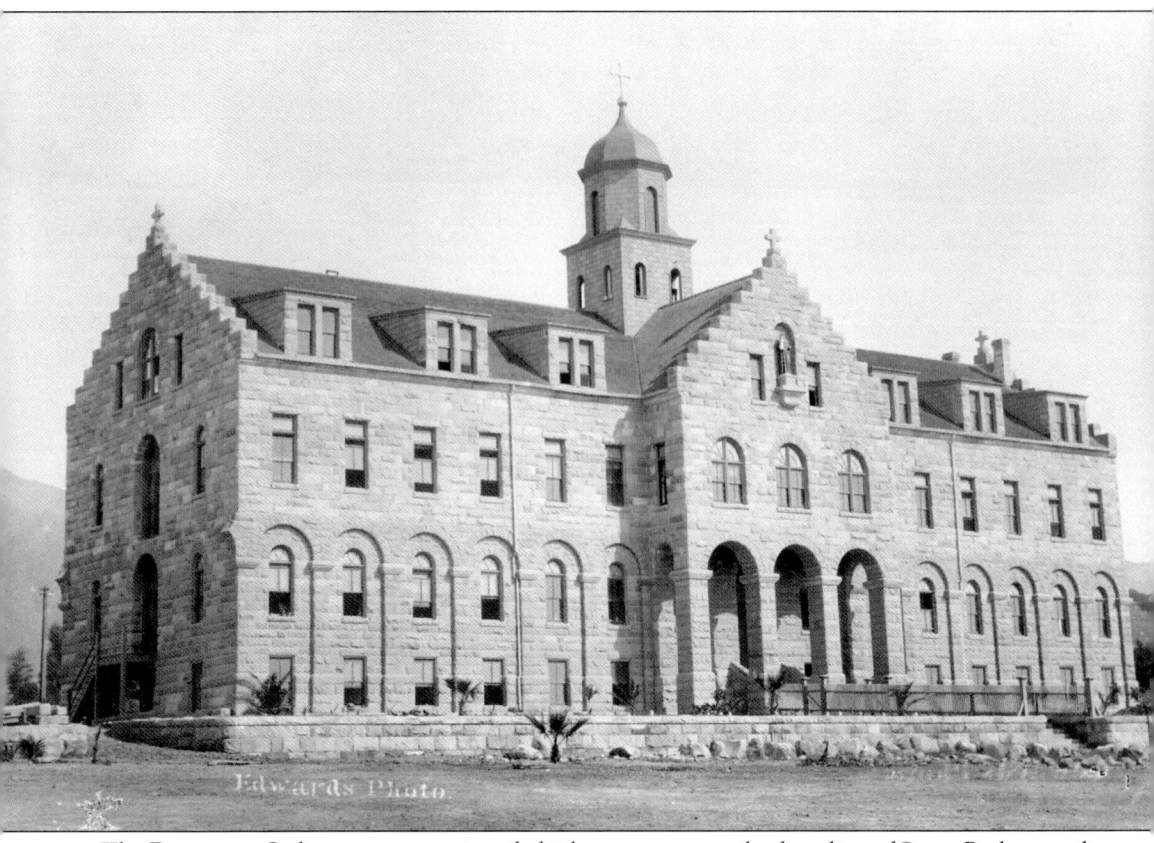

The Franciscan Order, a representative of which was present at the founding of Santa Barbara and at whose behest the beautiful Mission Santa Barbara was constructed, put down an additional root in the community with the building of St. Anthony's Seminary. Choosing a hilltop site near the mission and, following what was becoming a Santa Barbara tradition, quarrying and shaping the sandstone on-site, the padres laid the first stone on October 10, 1898. The cornerstone followed in June of the next year, and the Franciscans' primary teaching institution on the West Coast opened in 1901. St. Anthony's had another direct connection to Santa Barbara's founding, as master mason Antonio Leyva's great grandfather, Augustin, was in the detachment of soldiers present at the city's creation in 1782. As one of the speakers at the dedication of the seminary building intoned, "the new stone edifice is a lasting memorial to the zeal of its founders, a monument to the pride of those who brought it to life—the Franciscans of the West." It was also a jewel in the crown of Santa Barbara's stone architecture. (SBHM.)

Unfortunately, the "lasting memorial" survived less than a quarter of a century, as the massive earthquake of 1925 severely damaged the structure. St. Anthony's was quickly rebuilt, and though the top two stories were constructed of wood and stucco rather than stone, the builders maintained the beauty and grace of the original. Over the succeeding years, the school and its buildings were greatly expanded, creating a complete campus for the training of Franciscan friars. In more recent times, the Santa Barbara community has had access to the building, and it remains not only useful but still a classic representative of the city's early stone architecture. (Above M. L. Days; below SBHM.)

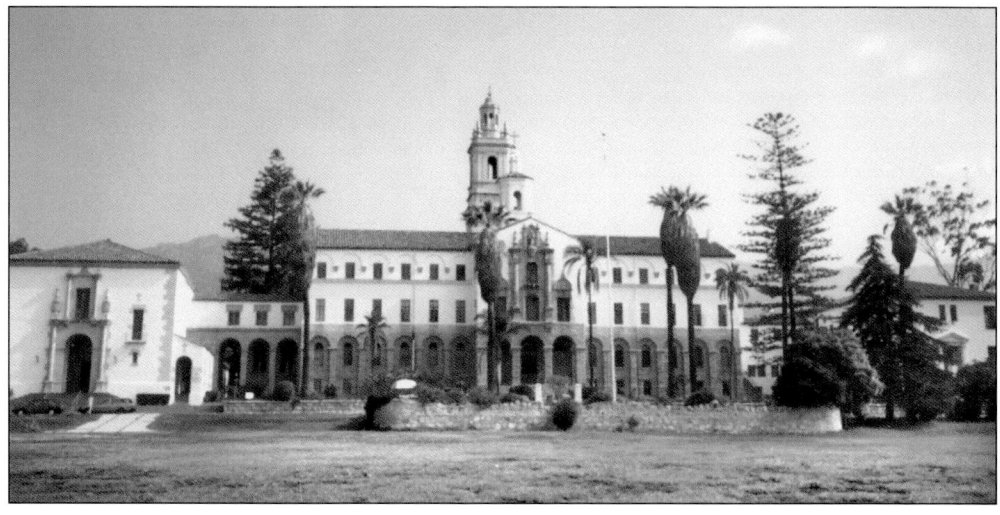

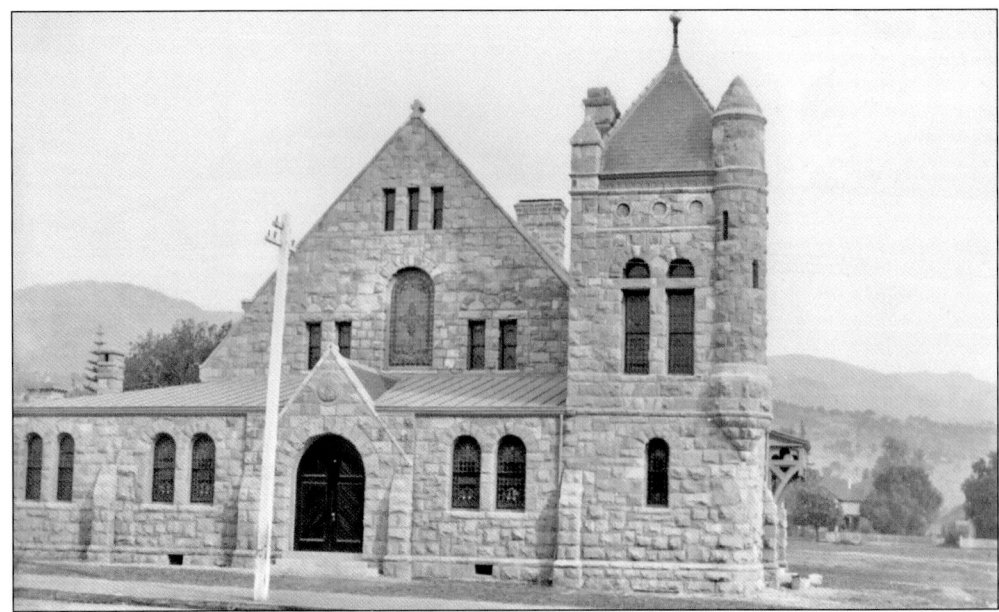

One of the early stone classics constructed in Santa Barbara was the original Unitarian church. Its builder, Englishman Thomas Hogan, had come to Santa Barbara by way of New York about 1887 and received the contract for the church in 1890. This photograph demonstrates not only that Hogan was clearly a master of his trade, but that he also had an artist's eye for design. (SBHM.)

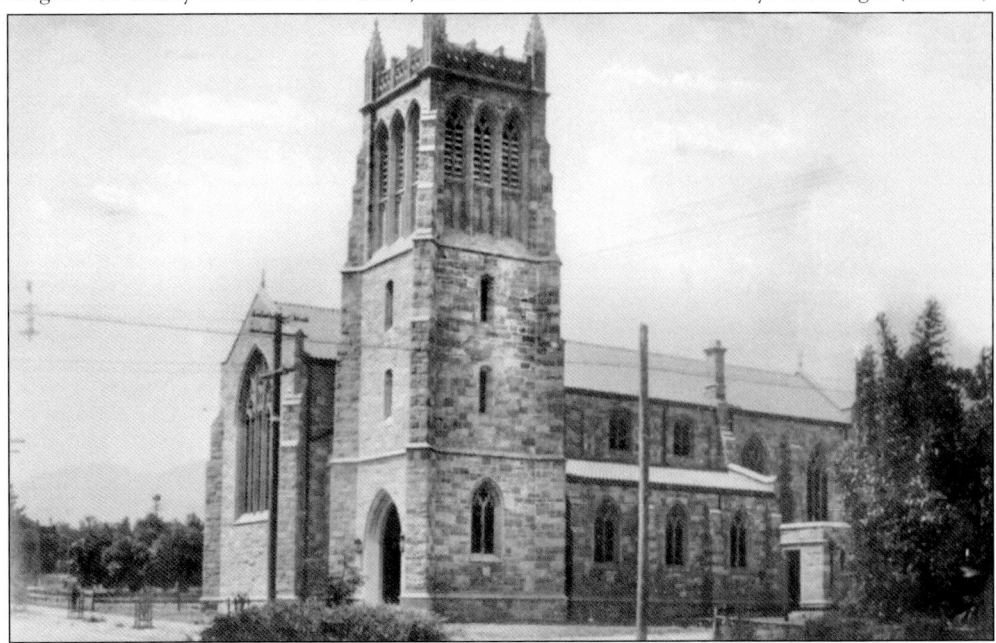

The Trinity Episcopal Church, at the corner of Micheltorena and State Streets, has been a landmark since its consecration in 1919. It was designed by Martin and Frohman, later to become the construction supervision architects of the National Cathedral. The structure is load-bearing stone with a steel reinforced mortar and rubble core; many of Santa Barbara's best stonemasons worked on it under the direction of Peter Poole. It was badly damaged in the 1925 earthquake but was rebuilt and has been beautifully maintained since. (SBHM.)

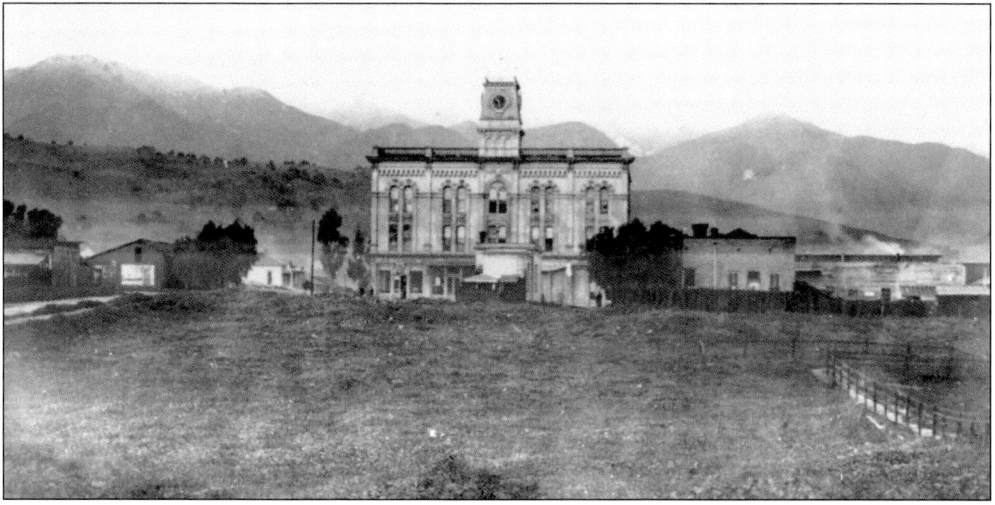

Superb stonework marks the base and bell tower of one of the most charming churches on the south coast, All Saints by the Sea Episcopal Church. Now a local landmark, the rustic building whose cornerstone was laid in September 1900, is the design of architect A. B. Benton of Los Angeles, and its meticulous construction is the work of contractor F. A. Johnson. It remains as it was built, a testimony to the skills of its creators and an asset to the community. (SBHM.)

Santa Barbara's first banker, one-time mayor, and visionary developer Mortimer Cook built this solid-looking stone edifice in 1875. He presciently located it at the corner of State and Carrillo Streets, and the city eventually grew up around it. Cook, however, did not share in that growth, as he went broke trying to develop the building. The structure stood as a landmark until 1925, when it was destroyed in the earthquake. (SBHM.)

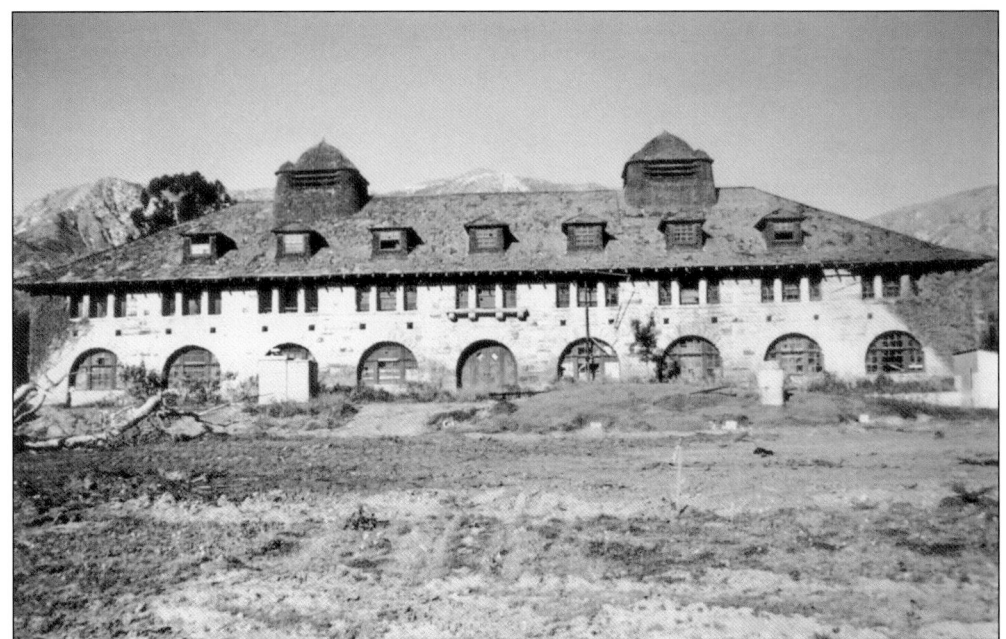

The classic stone building above was the lemon packing plant on the Crocker-Sperry Ranch in Montecito. A large crew of talented Chinese laborers, abetted by Scottish masons Thomas and Peter Poole, laid the cornerstone of the 175-by-63-foot building in November 1891. Though the ranch remained in operation for many years, eventually the rising value of the land rendered Crocker-Sperry inoperative. The property was subdivided, and the East Valley Ranch Company acquired a portion in 1964 for the development of the Birnam Wood Golf Club. Recognizing the classic lines, the superb stonework, and the lasting value of preserving a portion of the region's past, Birnam Wood refurbished the old packing plant, remodeled the interior, and created the clubhouse that now serves the membership. (Both, SBHM.)

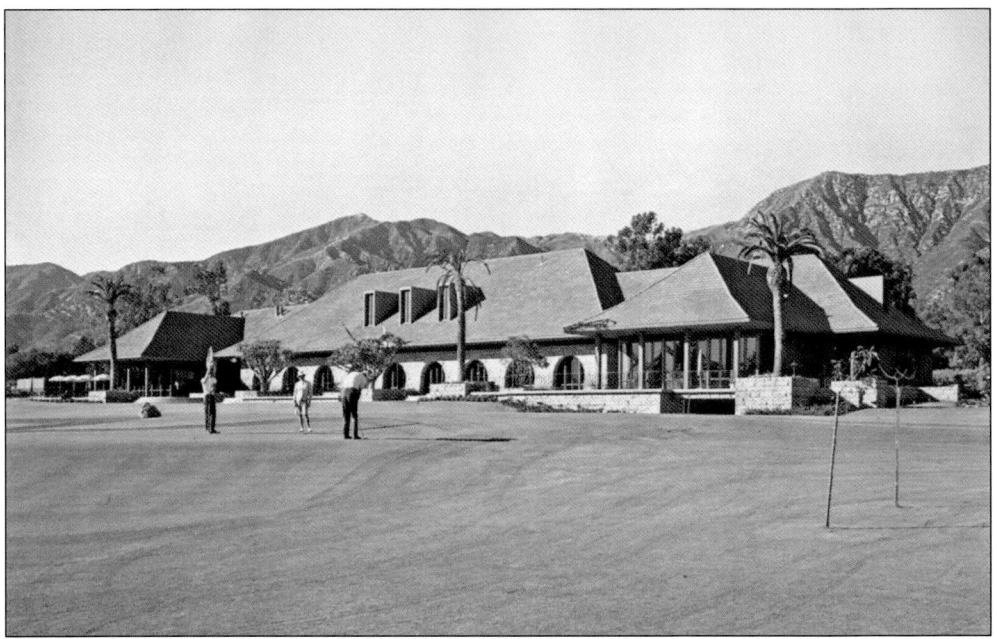

Born and raised in the Lake Como region of northern Italy, John Goggia grew up in the stonemason's trade. Immigrating to the United States, he appeared in Santa Barbara before 1890 and quickly rose to prominence as a master mason. In 1906, he demonstrated his skill in building the Montecatini Hotel, commonly called the Nardi Hotel after its celebrated owner, Frank Nardi. Goggia's work eventually fell victim to modern times. (SBHM.)

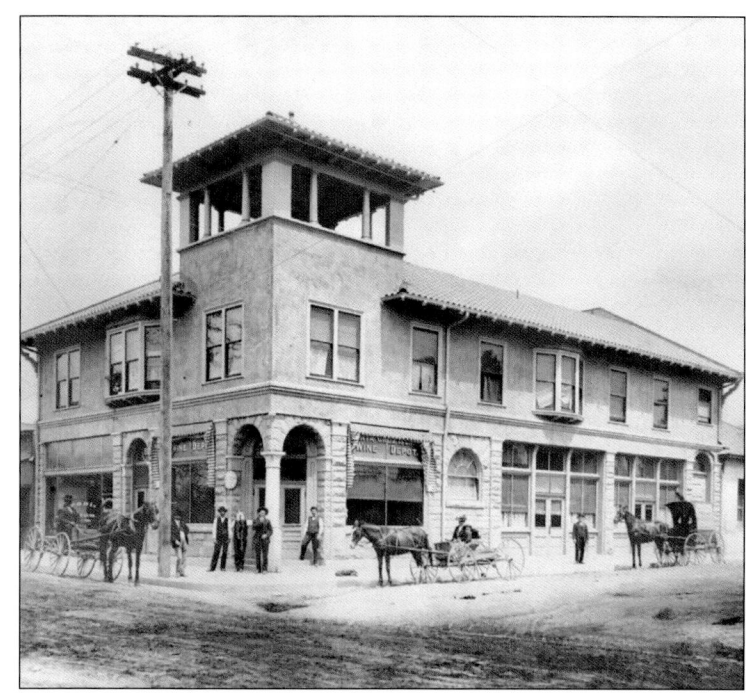

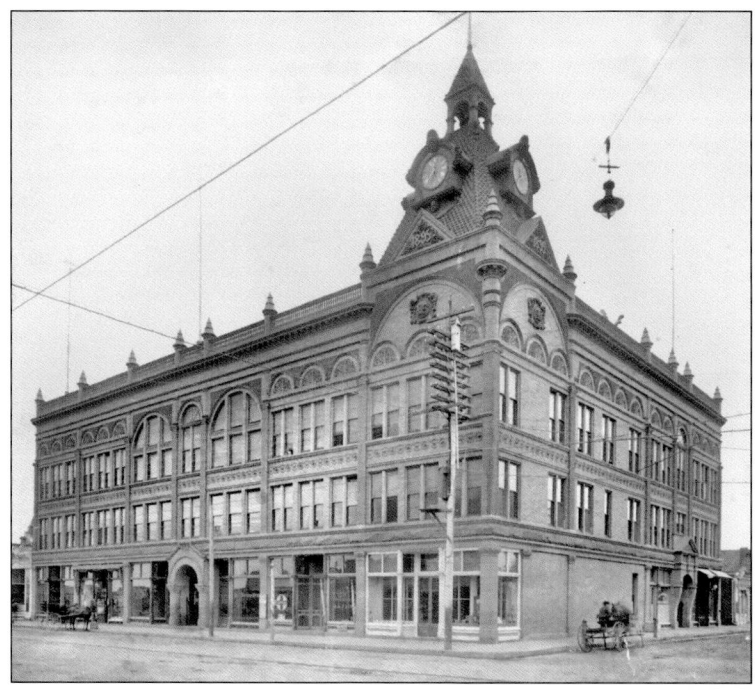

In 1895, pioneer quarryman Thomas Hogan received the contract to provide the cut stone for the proposed Fithian Building to be constructed at the corner of State and Ortega Streets. The first floor was erected on Sespe brownstone pillars, which supported massive four-ton lintels between the posts, a fine example of sturdy stone construction. It fared much better than its neighbors in the earthquake of 1925. (SBHM.)

15

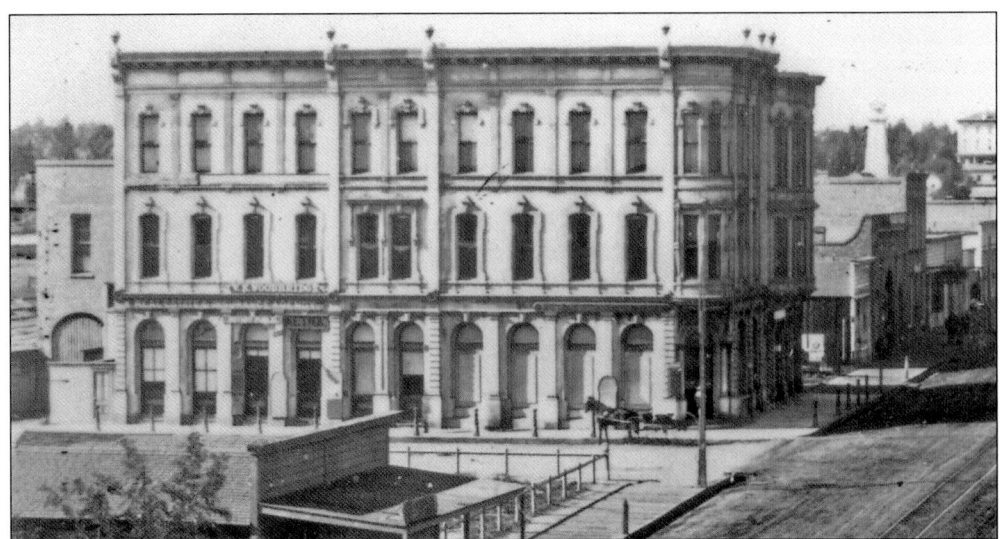

Mortimer Cook arrived in Santa Barbara in 1871 with $100,000 in his pocket. He immediately rented space and advertised himself as the Private Bank of Mortimer Cook, thus initiating the banking industry in the city. Prosperity came quickly, as did a national charter in 1873, creating the First National Gold Bank of Santa Barbara. Properly ensconced in this ornate stone structure on the corner of State and Canon Perdido Streets, the bank was poised for a profitable future. During the bank panic of 1877 in California, the anticipated run on First National Gold was thwarted by local millionaire Col. W. W. Hollister, who stationed himself at the bank's doorway and promised all depositors he would back their money with his personal gold. In 1890, the bank wisely dropped gold as its basis and became simply the First National Bank. It eventually built this new home of classic stone. (Both, SBHM.)

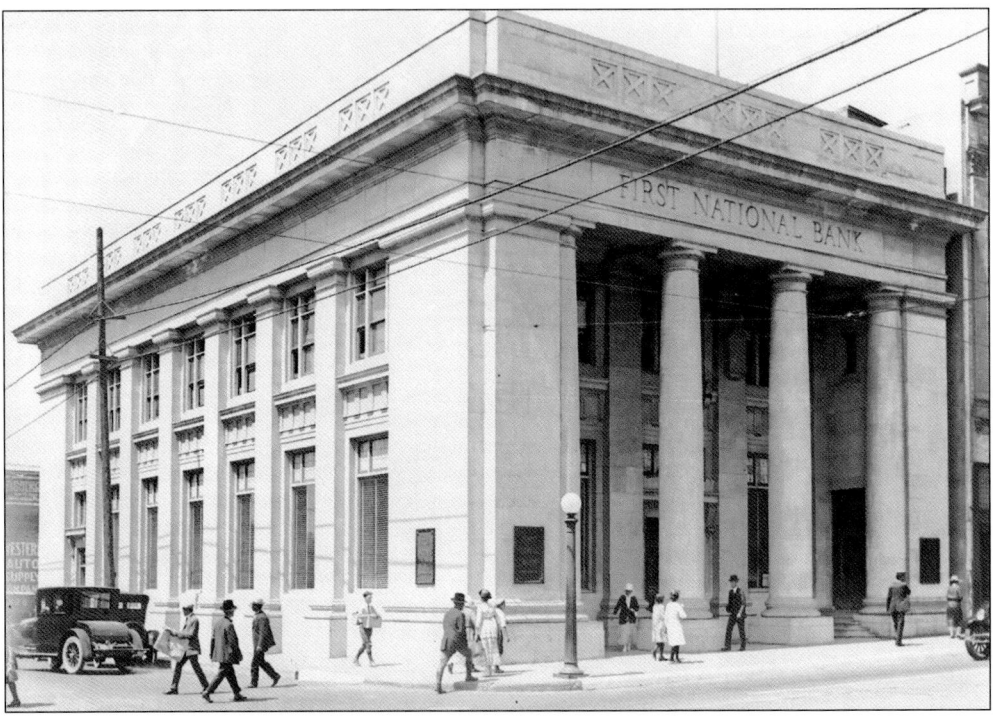

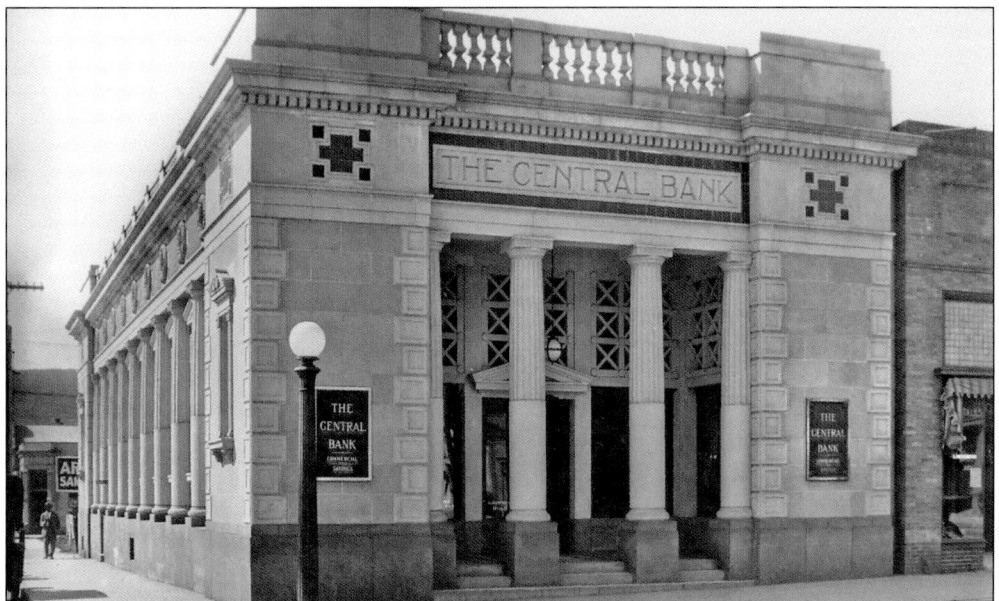

The Central Bank, once situated at the corner of State and De la Guerra Streets in downtown Santa Barbara, appears here as the epitome of security in stone. The classic architecture and beautifully carved details made it stand out, even among the many fine stone structures in town. It was local in nature, headed by its longtime president T. Wilson Dibblee, a descendant of the locally prominent de la Guerra family. (SBHM.)

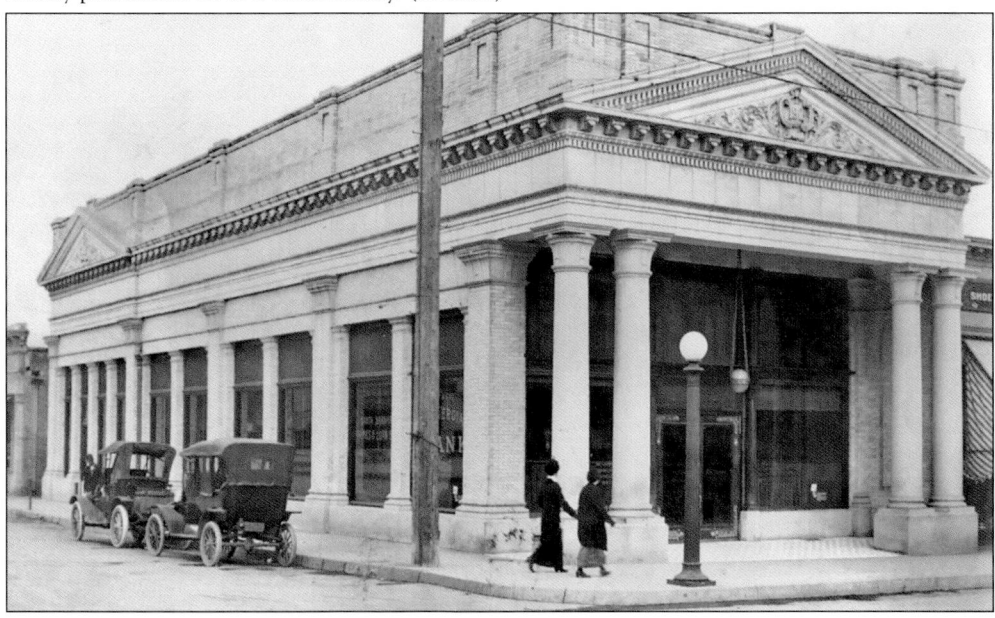

The Commercial Bank, built in 1903 by Fred Henderson's crew, was a massive undertaking. Three-ton cornerstones held up the 14-foot columns, which, at the time, the *Santa Barbara Morning Press* called, "the heaviest stone work ever put up in the city." Times changed, and the bank building at the corner of State and Canon Perdido Streets was severely modified over the years. But stones are forever, as a work crew excavating for new construction in 1991 found out when they unearthed the bank's original pillars. (SBHM.)

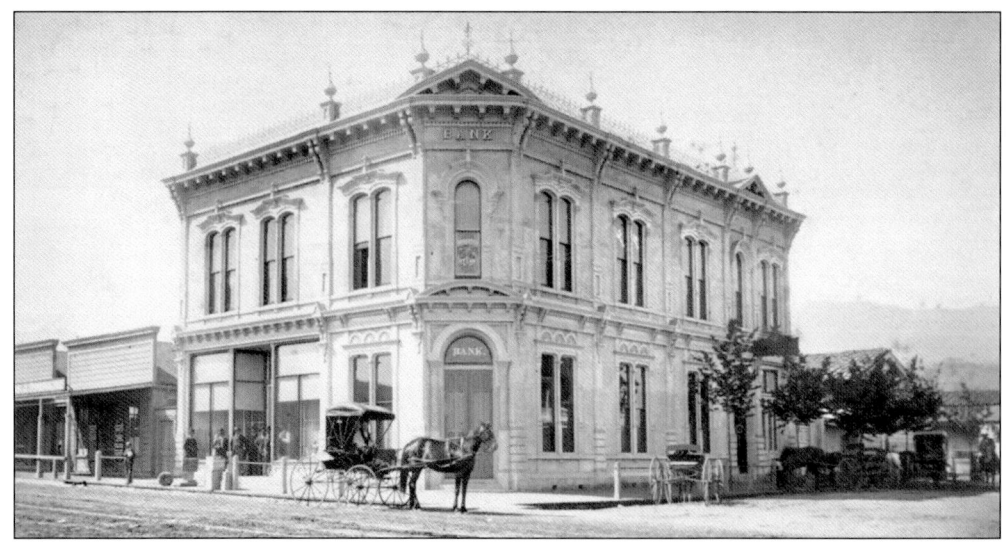

On November 1, 1875, William Eddy opened the County Bank in a State Street storefront. He received a charter for County National Bank in 1880, and a year later, he moved into this classic stone structure. Eddy not only prospered but survived the Panic of 1893 when, anticipating a run on the bank, he filled his front windows with trays piled with gold coins to demonstrate his solvency. It worked, and his success stimulated the city's growth. (SBHM.)

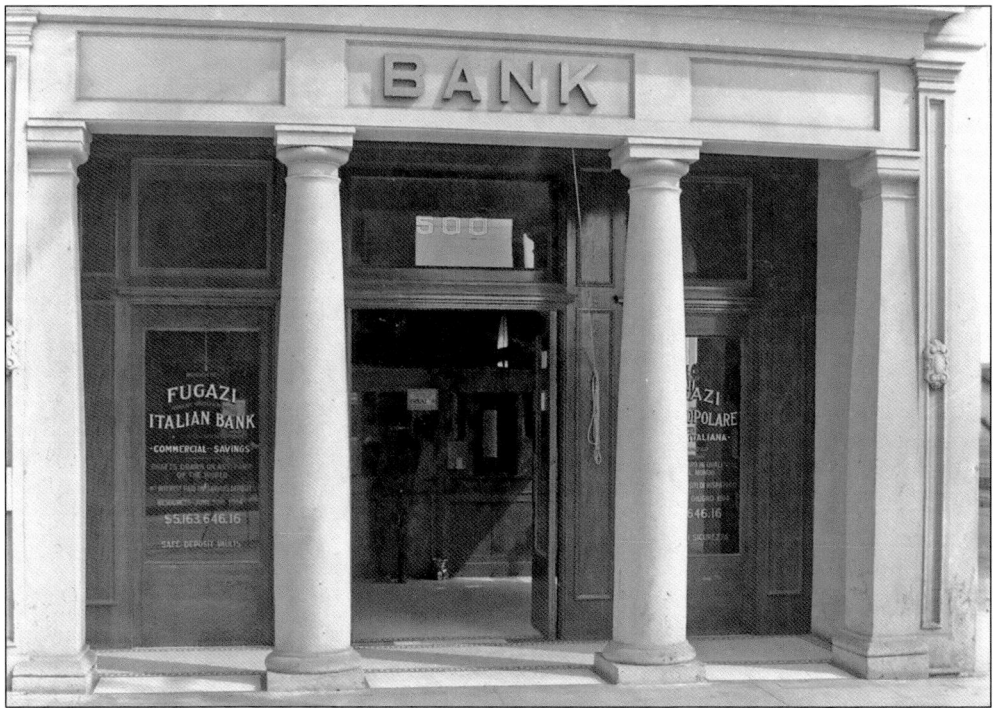

Specializing in agricultural loans and heavily patronized by the local Italian community, the Banca Populare Fugazi opened in this fine stone building in 1913. Surviving the earthquake of 1925 but unable to do business on shattered State Street, Fugazi set up a tent on the corner of Cota and Anacapa Streets and did business there for a couple of weeks, thus making it an appropriate candidate to be absorbed into the Bank of Italy and, eventually, the Bank of America. (SBHM.)

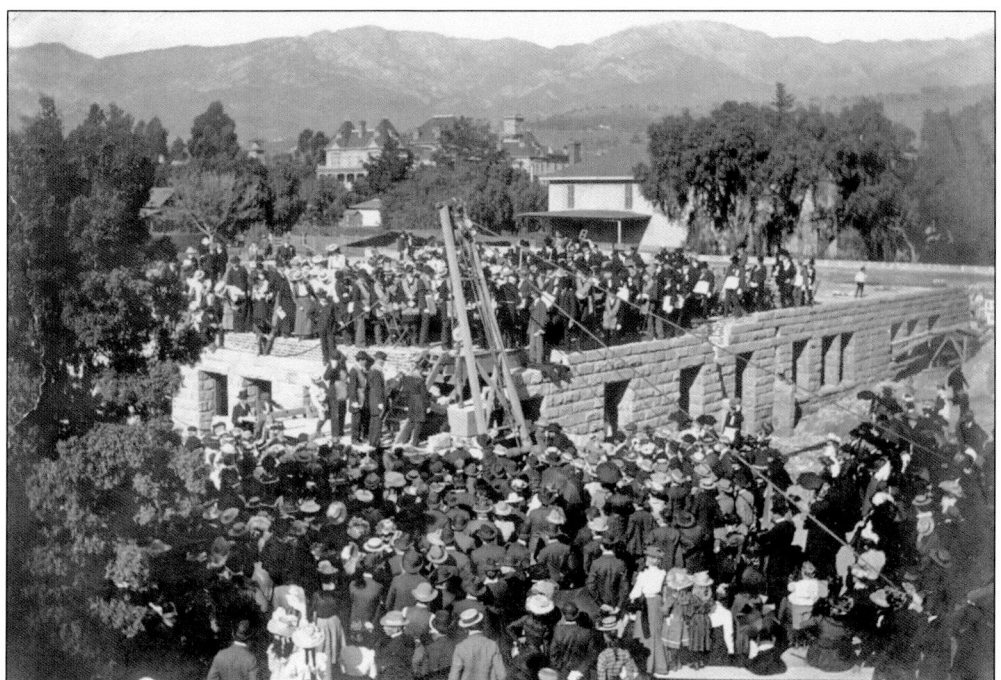

When Santa Barbara finally decided to build its first high school, the school board planned for permanence. Aware of the availability of a cadre of excellent stonemasons and the easy access to raw materials, the board determined that the building should be made of stone. The board contracted with Los Angeles architect John Kremple to design what turned out to be this magnificent three-story stone structure. Laying the cornerstone on November 30, 1901, became an all-city affair, as the Masonic lodge, aided by some 400 school children, promoted the well-attended event, and the city looked proudly on as students occupied the structure a year later. (Both, SBHM.)

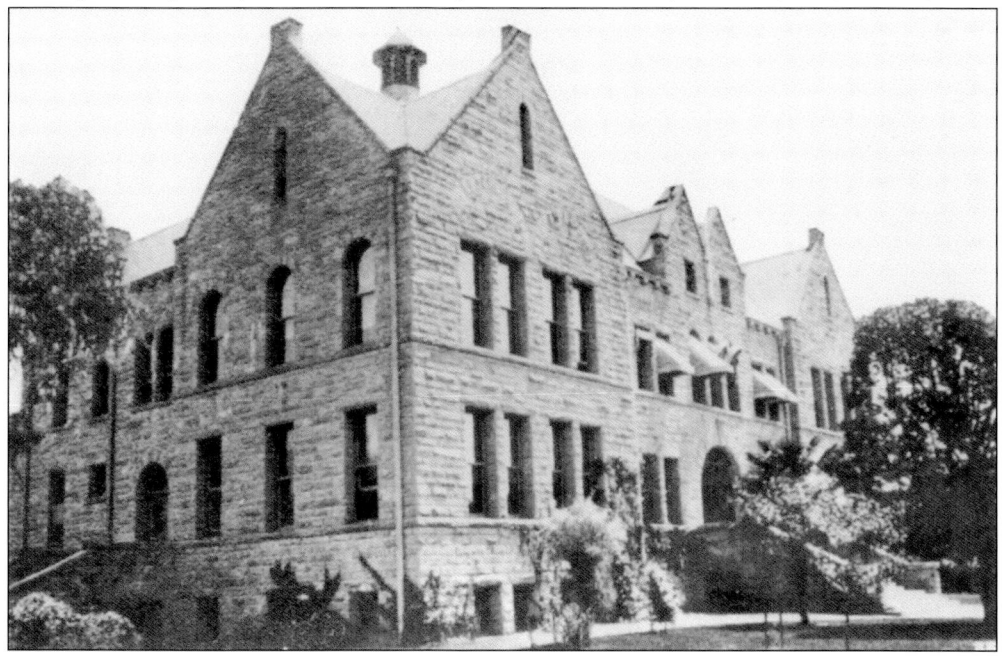

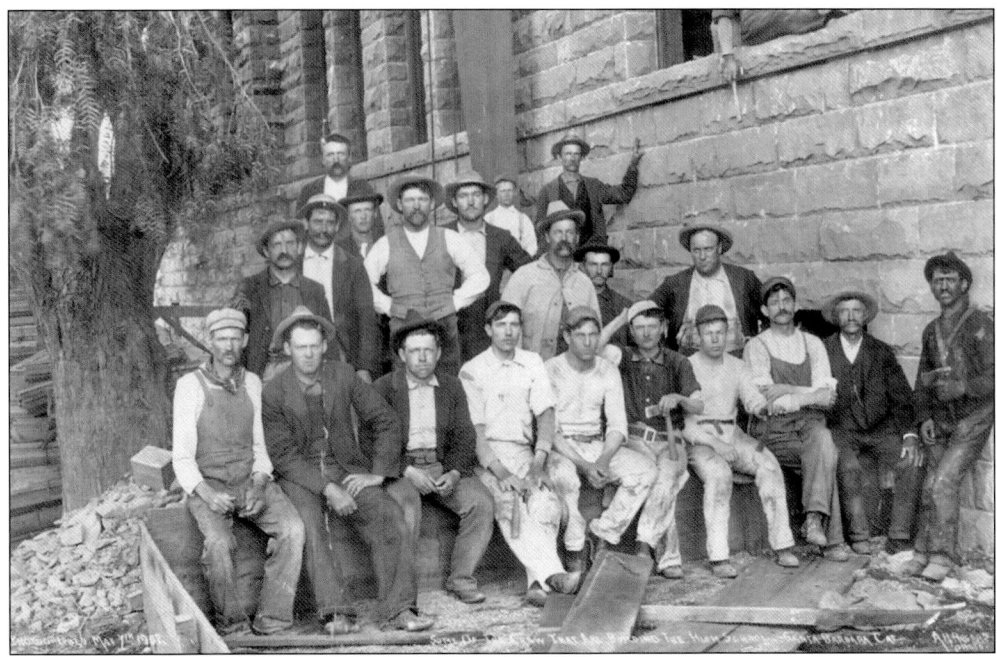

The original construction crew, which posed proudly for this photograph as the high school neared completion, must have been devastated when the earthquake damaged the building so severely that it had to be torn down. The stones were scattered throughout the city, turning up again as portions of walls, bridges, and other stone structures. Only a stone marker remains at the corner of De la Vina and Anapamu Streets to indicate the location of the school and to preserve the memory of one of Santa Barbara's finest examples of stone architecture. (Both, SBHM.)

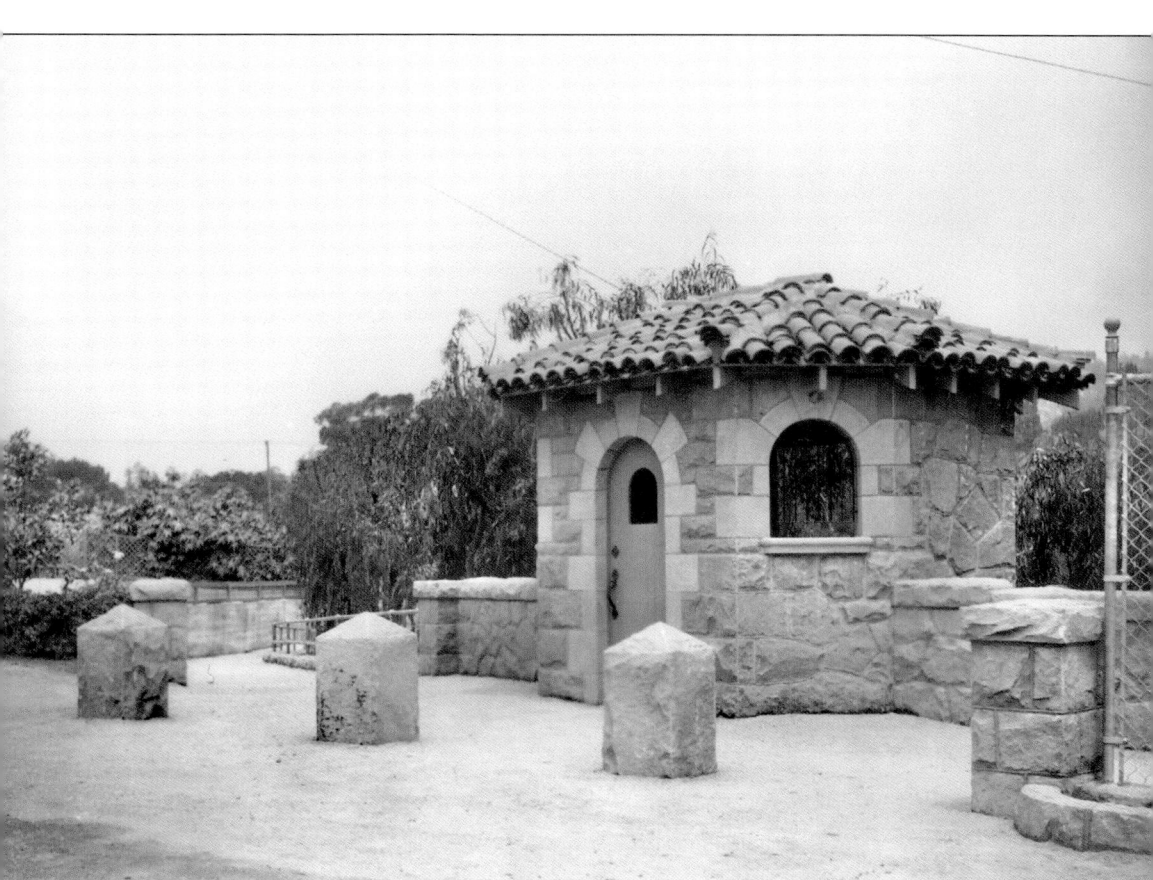

Fortunately, Santa Barbara was prepared for the loss. The city's population had burgeoned in the first decades of the 20th century. It tripled between 1902 and 1920. By 1923, over 500 students were crammed into the not-so-old high school, and Santa Barbara faced the prospect of building anew. In 1922, after several attempts, a school bond issue was approved, and a new high school, all steel and concrete, was ready in 1924. Though the new Santa Barbara High School was eminently modern, the board did not entirely ignore its past. In a fit of inspiration, it chose Italian stonemason Antonio Da Ros to add a bit of history to the new campus. Da Ros, who had come to the United States around 1910 and to Santa Barbara in 1915, had served in the army in World War I. Returning to Santa Barbara after the war, he became a stonemason. He not only built walls and lined walkways with stone but also erected this charming ticket booth to serve the new athletic fields, a job it continues to perform for the latest generation of students. (SBHM.)

Santa Barbara's first federal post office building opened in 1914 and shared the distinction with Pasadena of being the only two post offices in the nation with non-conforming architecture—that is, a different design from the government's factory-like post offices going up everywhere. Part of the non-conformance was not only the design, but, in this case, the incorporation of a wealth of stone on both the interior and exterior. (SBHM.)

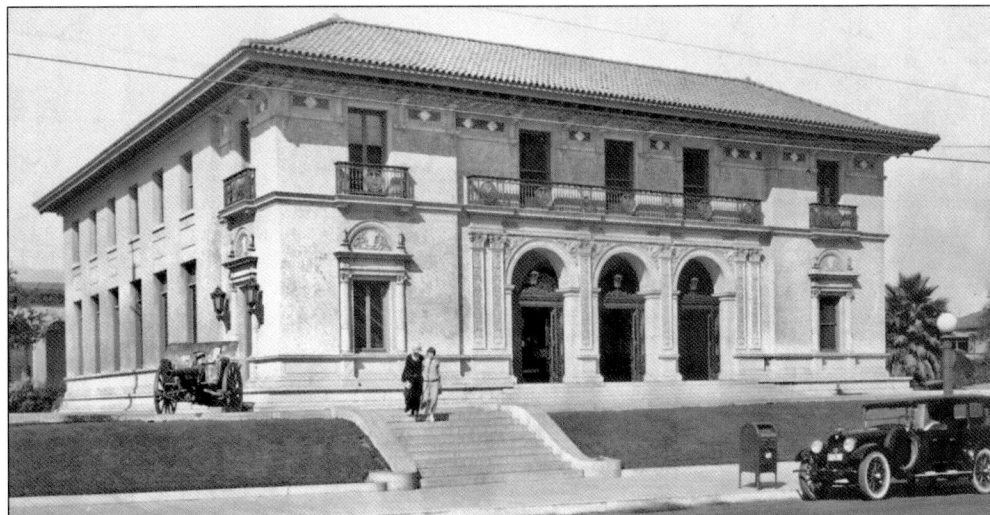

The finished product was a prominent addition to the city and helped extend the business district up State Street. Though it lasted less than three decades as a post office, the edifice remained and, in 1941, became the Santa Barbara Museum of Art. The building looks now much like it was originally described by an orator during the building's dedication, "stately, massive, beautiful, an heritage to the people of Santa Barbara, their children, and their children's children." (SBHM.)

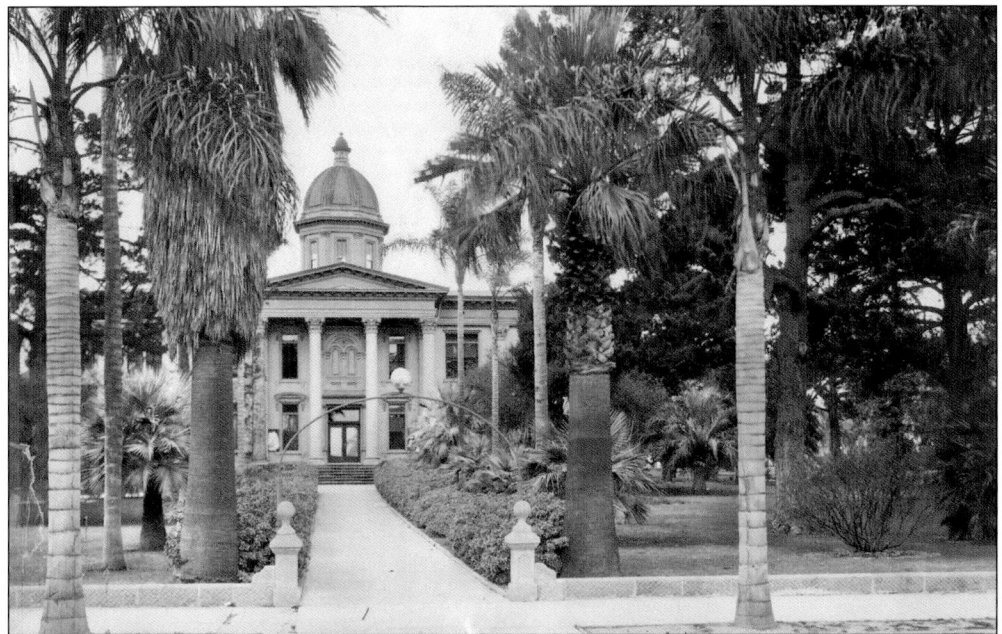

Santa Barbara's first courthouse, built in 1873, was the standard 19th-century classically styled government structure. Designed by architect Peter Barber, who chose to defy Santa Barbara's traditional adobe style, it featured four Corinthian columns holding up the entrance arch and 34 pilasters supporting ordinary brick walls. It provided the then-popular imposing image of stateliness and stability. Unfortunately, it was shattered by the 1925 earthquake. (SBHM.)

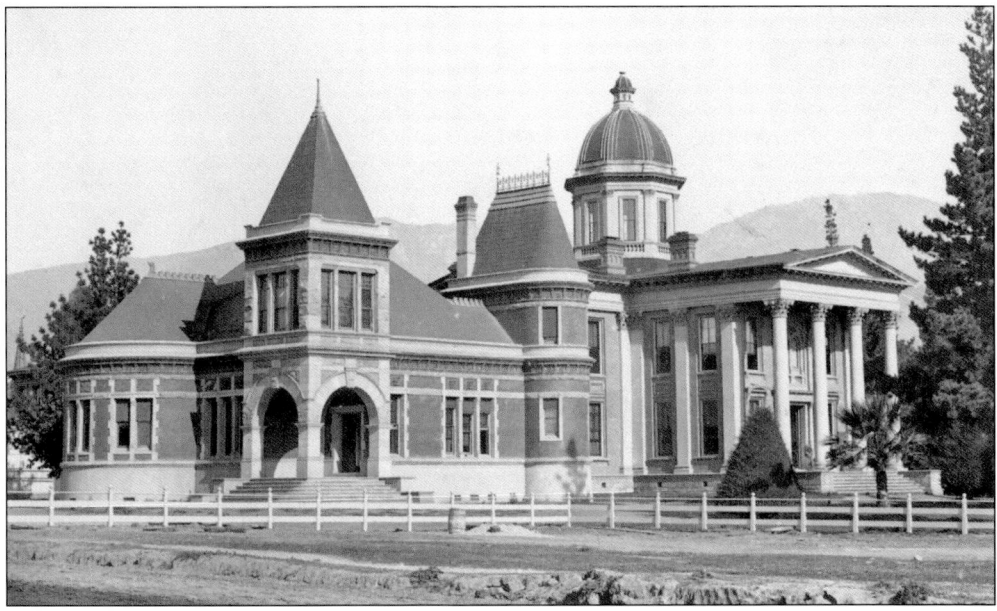

The first courthouse was expanded in 1889 with the addition of the adjacent Hall of Records. Its signature feature was the "fine stone entrance," a double-arched corner shading the entrance door. When the supervisors accepted the building, a *Santa Barbara Morning Press* reporter on the scene remarked, "On the whole, it is a handsome building," although, said another, "Just what the particular style of architecture it is, is hard to determine." (SBHM.)

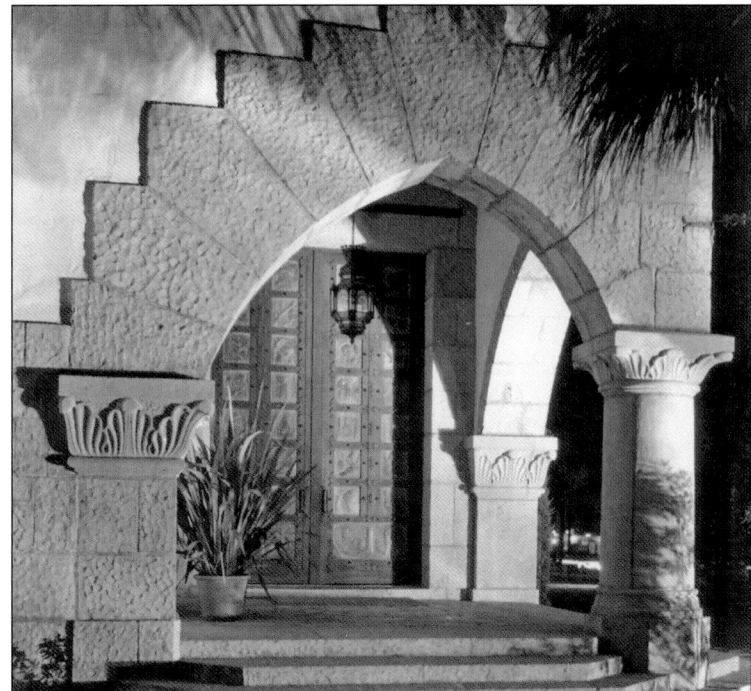

Though there was rubble all around it, the striking entrance to the courthouse Hall of Records easily survived the 1925 earthquake, and when the new courthouse was built, that entrance was kept as part of the design. The graceful arches, with their finely tooth-chiseled stones and single pillar, still grace the Hall of Records and provide a beautiful connection to an earlier Santa Barbara. (SBHM.)

Upon completion of the Hall of Records in 1889, the supervisors asked for bids for a fence to be built around a portion of the grounds. Clarence E. George, who had come to Santa Barbara in 1876 from Rutland, Vermont, won the contract. By the end of 1890, the stones for the fence were dressed and installed, as was what Patricia Cleek described in "Santa Barbara Stonemasonry," a "wrought iron gate between two stone posts crowned with ball finials." Over 100 years later, George's work still defines the courthouse grounds. (SBHM.)

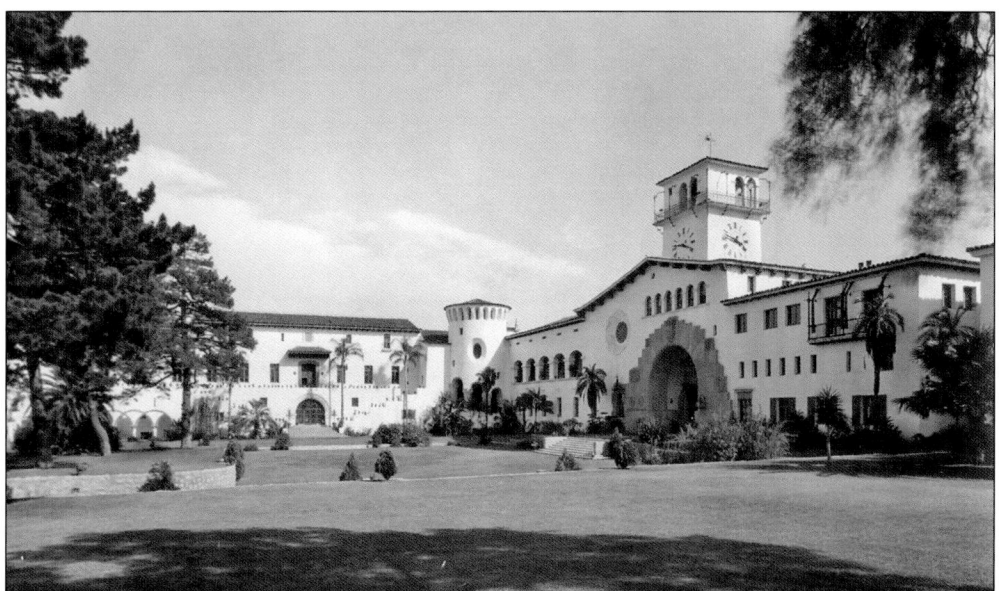

When it was opened in 1929, the new Santa Barbara County Courthouse was hailed by the Traveler's Insurance Company in *The Traveler's Protection* as "the most beautiful building in America." While that assessment might be arguable, the building certainly remains one of the most beautiful anywhere. Wrote the San Francisco architect who did the design, William Mooser II, "the secret of the picturesqueness of the Santa Barbara Courthouse is to be found in developing the structure and the various architectural effects to scale. In building the Santa Barbara Courthouse we tried to get back to the massive scale of buildings as carried out by the Spanish." Above is a view across the Sunken Garden with the Figueroa wing to the left and the Anacapa wing to the right. The photograph below details the arch leading to Anacapa Street and shows off the exquisite carving technique of master mason Giovanni Antolini. (Both, SBHM.)

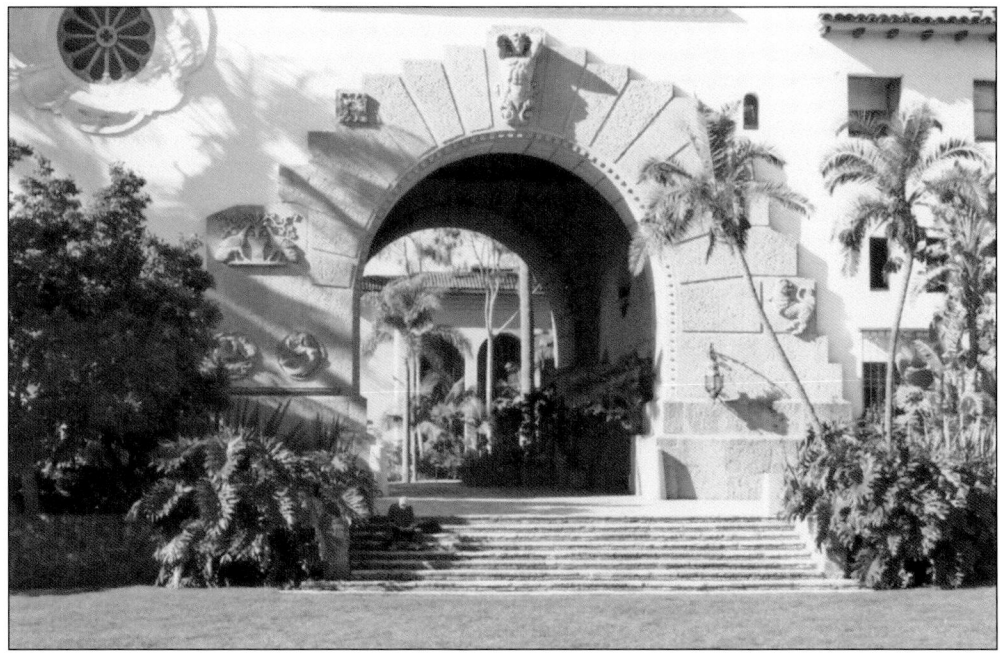

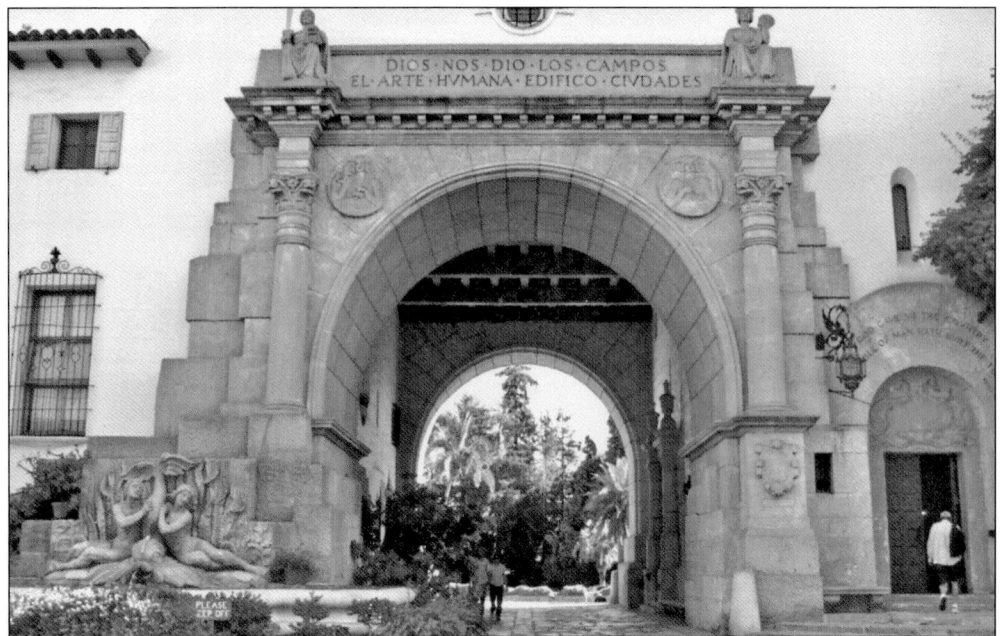

After the 1925 earthquake, engineers decided that concrete and steel provided better security than stone, but when it came to architectural effects, there was no substitute for carved stone. Here is the main arch from Anacapa Street featuring stone quarried in Refugio Canyon, some 20 miles west of the city. Some of the single stones mounted in the arch weighed more than nine tons. Obviously adapted from the old Roman triumphal arch, it provided a dramatic entrance to the building and the Sunken Gardens inside as well as a showcase for Antolini's crew of carvers and setters. Beside that entrance is a magnificent stone fountain, *Spirit of the Ocean*, carved by the talented Ettore Cadorin, the man also responsible for the statue of Junipero Serra gracing Statuary Hall in the nation's Capitol in the District of Columbia. (Both, SBHM.)

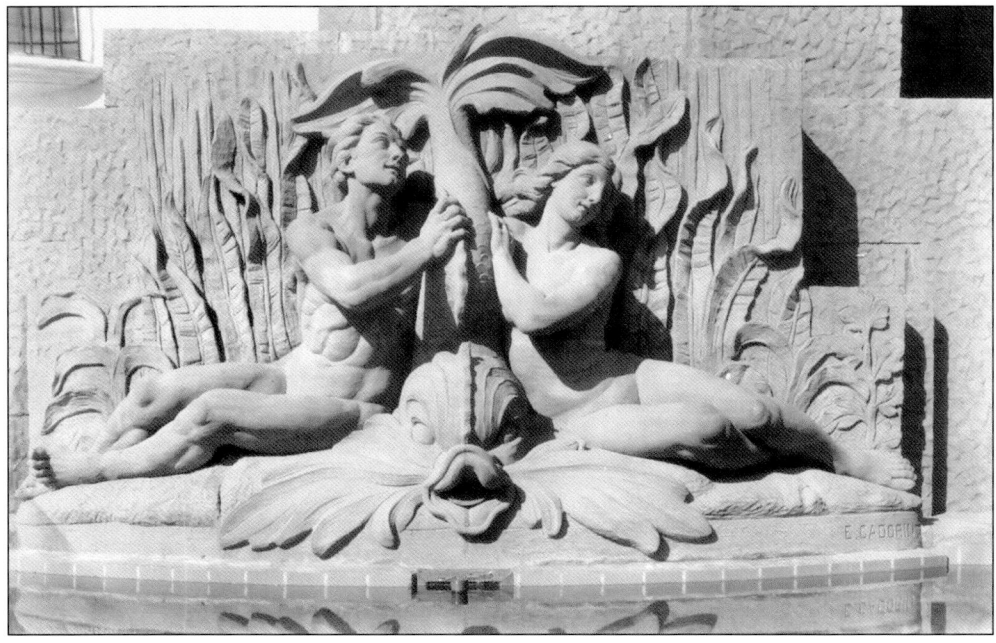

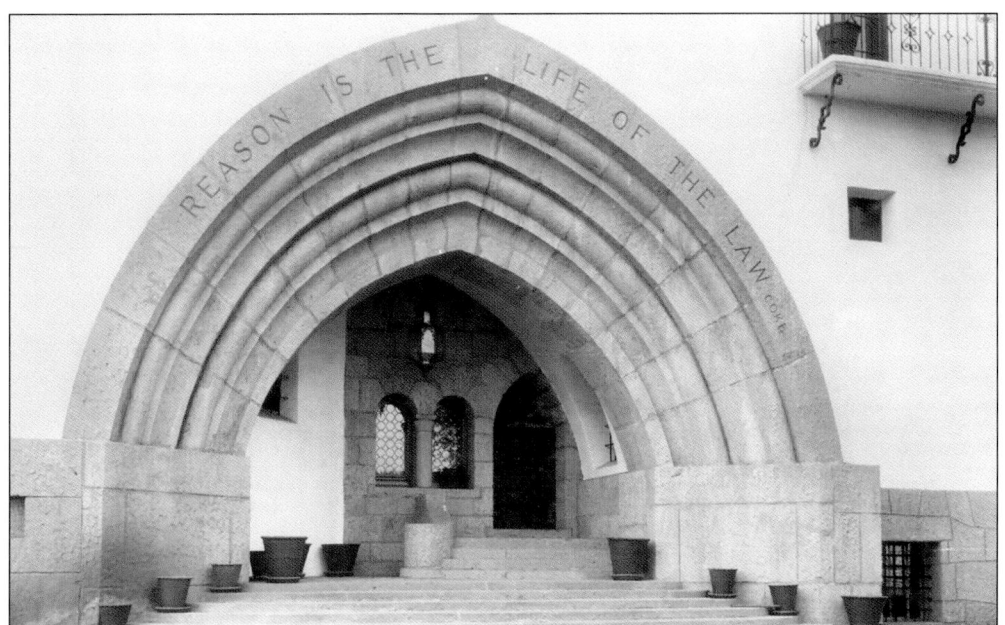

Echoing, perhaps, the entrance to the Hall of Records, this Gothic arched entry to the main lobby from Figueroa Street works with the overall Spanish theme primarily because of the nature of the stone. The consistent color, classical carving, and impeccable placement never fail to impress the entrant, while the gradually narrowing stone steps inevitably lead one into the building. (SBHM.)

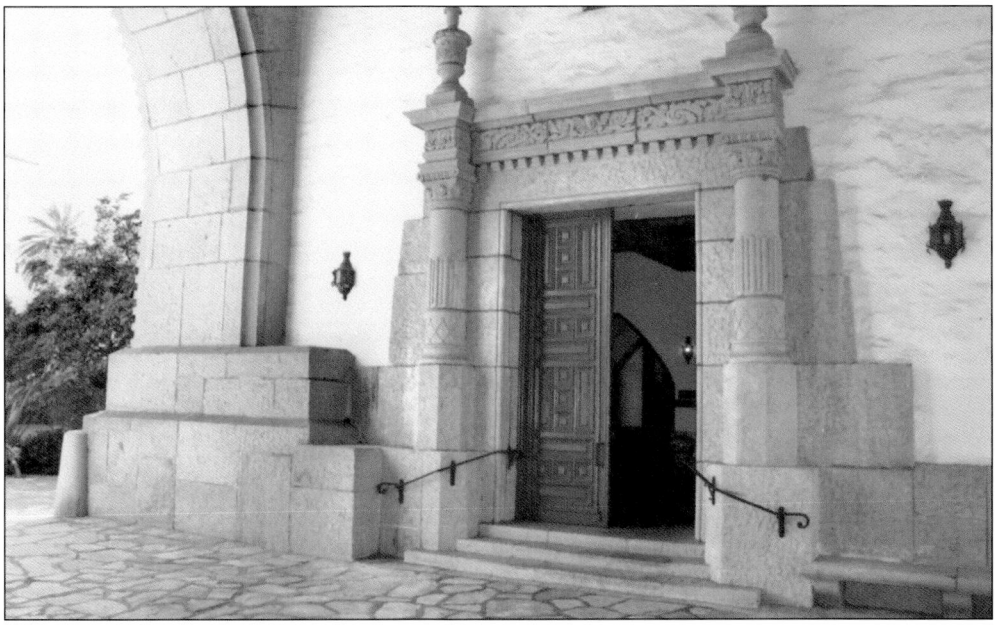

This entrance to the main lobby from under the Anacapa arch combines many of the techniques of the master stonemason. The flat blocks against the wall exhibit the cross-hatching used throughout, while the posts, whose blocks match the height of those behind them, show a variety of carving. The lintel above has finely detailed work, as do the finials on top of the posts. It is little wonder that the masons who worked on the courthouse took such pride in their participation. (SBHM.)

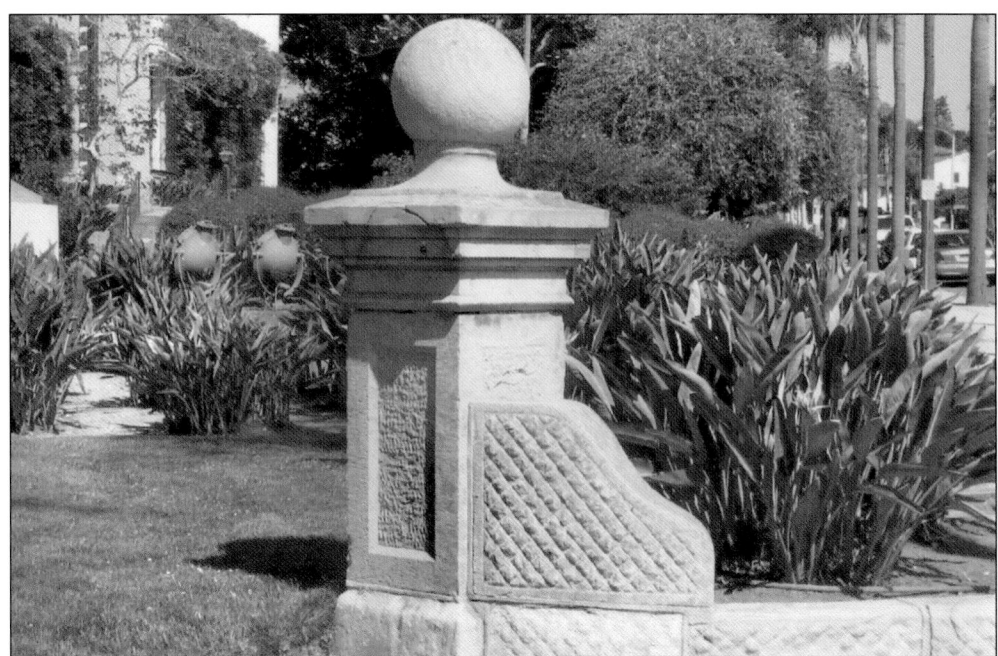

Though he died shortly before the new courthouse was opened, perhaps no one other than those directly involved could have been more pleased with its creation than stonemason Clarence E. George. George was the creator of the corner posts guarding the entrance to the original Hall of Records, and his low wall still remains around the entire city block. Two posts, like the one pictured, mark the diagonal entrances to the property from each of the four corners of the block. The round globes atop the posts were reputedly the work of Italian stonecutter Arcangelo Goggia. The crosshatched stones of the low wall, with smooth tops and beveled edges, form a perfect frame for the property and an unobtrusive protection for the extensive lawns and exotic plantings, all of which conspire to beguile the visitor. (Both, CONS.)

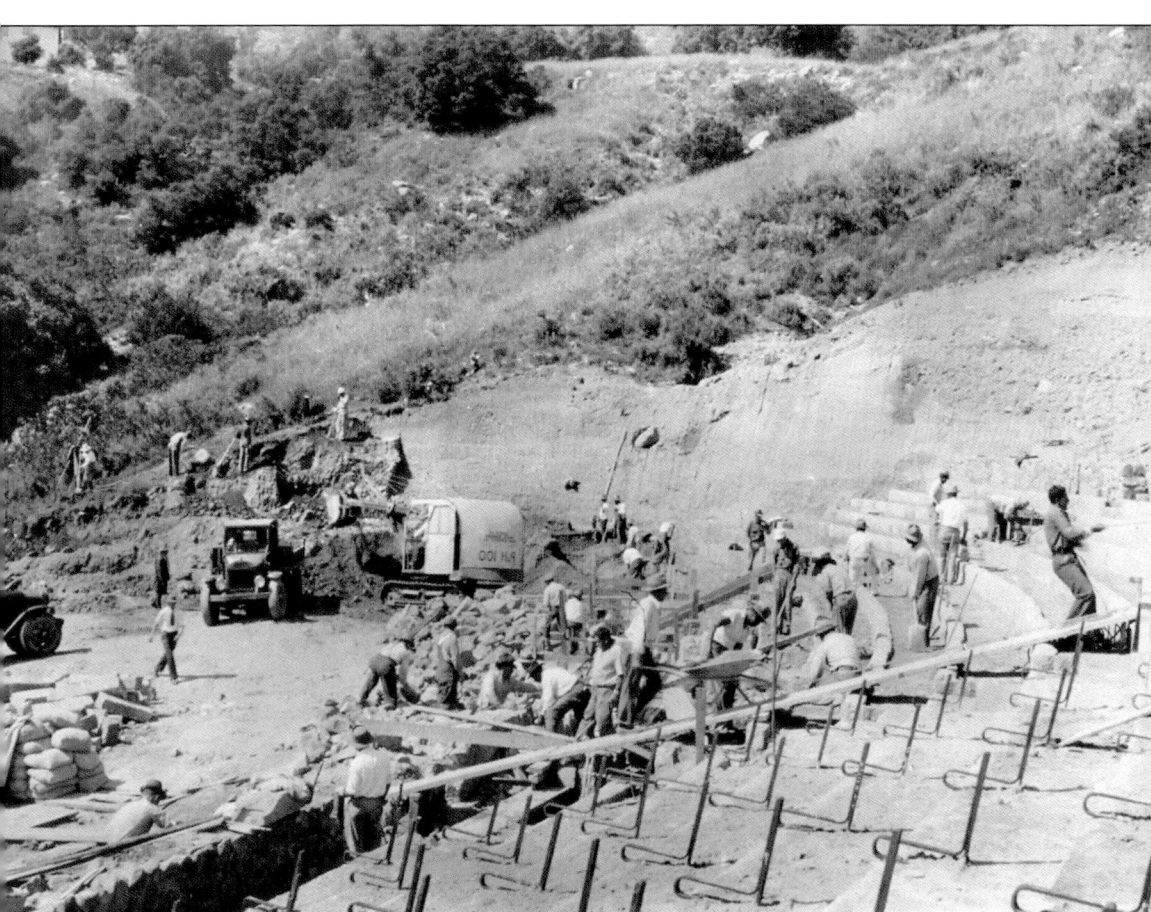

Despite the efforts of some of the large estate owners in Montecito, Santa Barbara's stoneworkers found it difficult to find enough work during the Great Depression to support their families. They were partially rescued by the county government, which was looking for construction projects to put people to work. Supervisor Sam Stanwood proposed the building of an amphitheater in a small canyon off the end of Anapamu Street as a venue for Santa Barbara's annual fiesta. He was joined by city benefactor George Batchelder, who donated a large portion of the property to the county, planner Wallace Penfield, and engineer Sam Ullman. The project was drawn up and submitted to Washington, D.C. It came back funded as a WPA project for some $77,000. The county put in another $30,000, and the Santa Barbara County Bowl was born. With ample resources on-site in the form of sandstone, stonecutters were immediately hired, work got under way in January 1936, and the bowl was completed the following August. (Santa Barbara Bowl Foundation.)

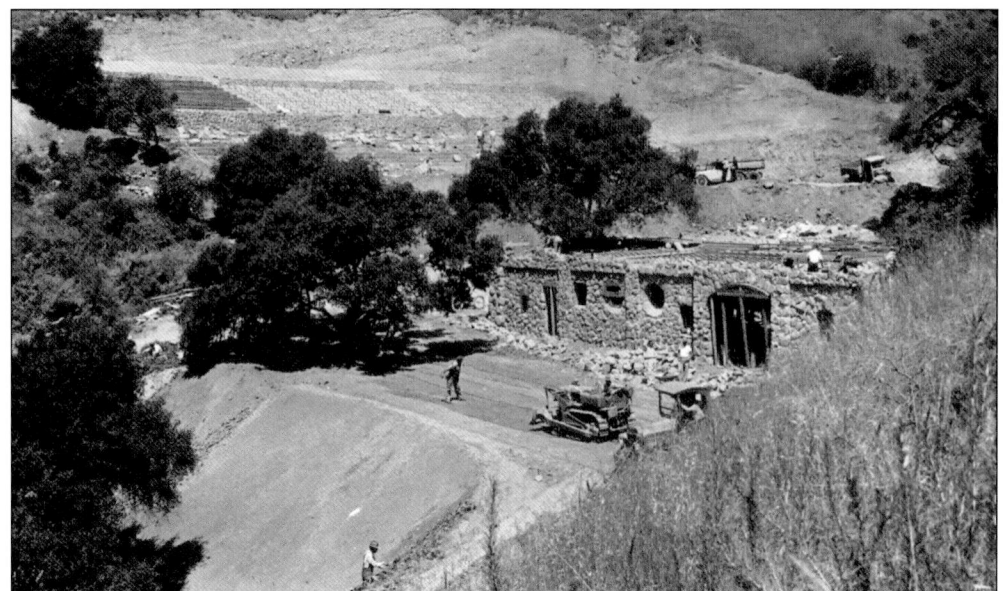

The *Santa Barbara News-Press* gave the stoneworkers their due but, unfortunately, not by individual name. "Skilled stonecutters who had originally been attracted to the area by the building of fine private estates did the work. The stone was hand quarried, hand hewn and polished, and carefully fitted into place." The Santa Barbara County Bowl, with all the varieties of stonework it offered, stimulated those who did the heavy lifting, and they appreciated the job they were given to do. Engineer Sam Ullman recalled, "the spirit of the workmen was amazing. Every one of them took a deep personal interest in the project. They'd come up on their days off to see that everything was going alright." The stonemasons of Santa Barbara were true artists, and fortunately, their handiwork is still here to see. (Both, Santa Barbara Bowl Foundation.)

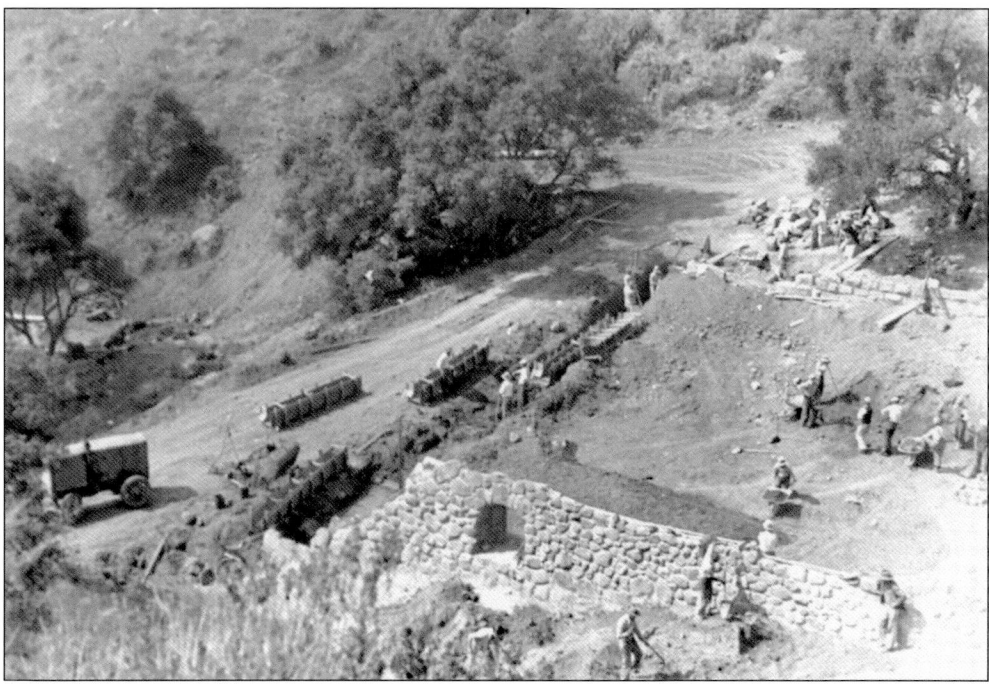

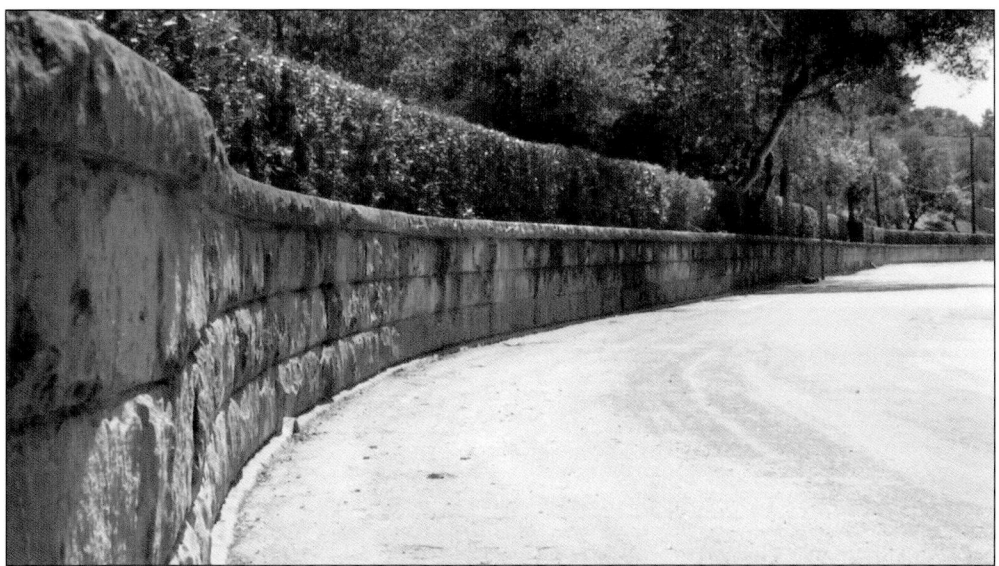

The Santa Barbara Cemetery, growing by fits and starts in the middle of the 19th century, joined the national cemetery movement toward the picturesque and embraced the use of stone in 1881 when it hired Samuel T. Moore, a local stonecutter, as sexton. The local Grand Army of the Republic unit furthered the movement in 1887 by installing stone curbing around veterans' lots. In 1894, Moore was contracted to build entry gates, and J. A. Pilcher was hired to build 400 feet of wall at the entrance. The more serious stone construction took place in 1910, when the cemetery board, in expanding and beautifying the grounds, hired Joe Dover and Fred Moore to construct 2,400 feet of wall, 4 feet high, 900 feet of which were to go to the west and 1,500 feet to the east of the entrance. Those walls, as solid and beautiful as any in the city, are as magnificent today as they were then. The west wall (above) and the east wall (below) have stood through earthquakes, weathering, and the pounding of tens of thousands of cars and trucks rumbling along beside them, vindicating the choice of the cemetery board to use stone. (Both, CONS.)

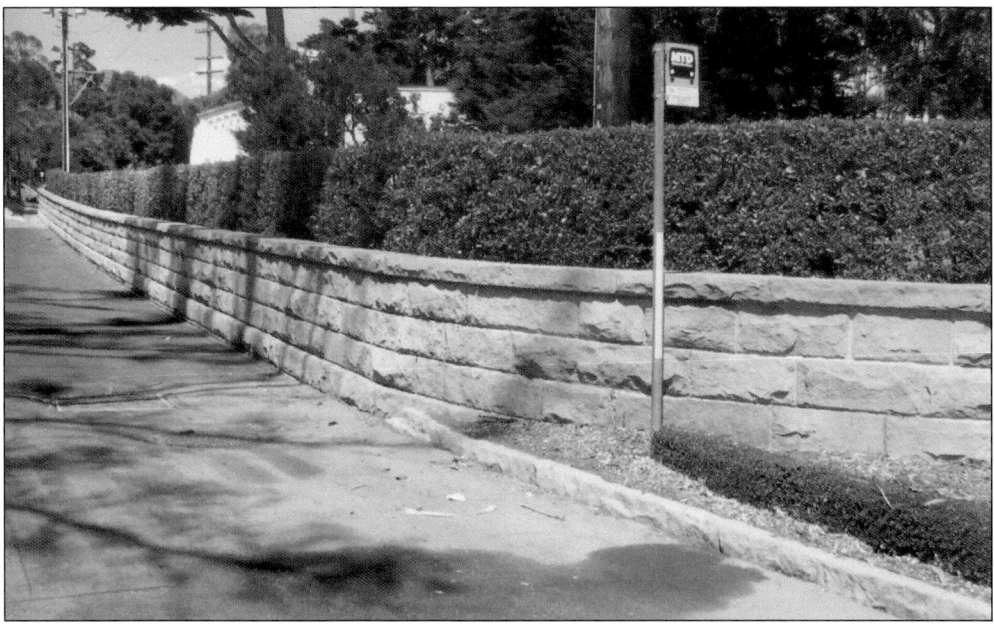

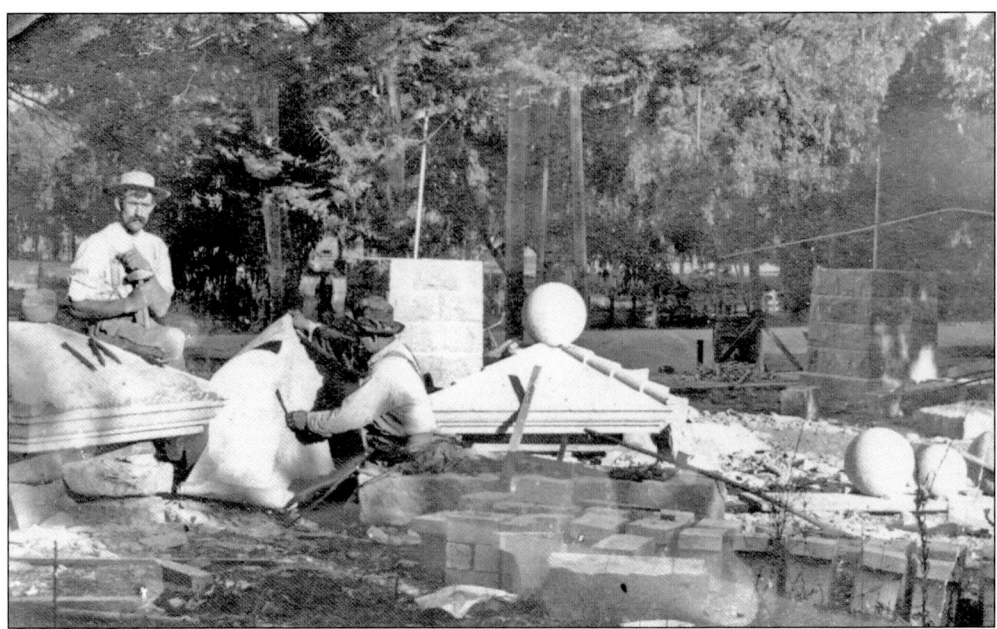

The wall project, designed by Thomas Nixon, proved so successful because it defined the portion of the cemetery's perimeter facing the public, it held up a section of the hill on which it stood, and it added to the beauty of the property. The contractors were hired to modify the original entrance to match the new wall and to create an entirely new gate at the entrance. A local newspaper enthused about the project and indicated that the new "gateposts will have stone caps five feet wide." The upper photograph shows a gatepost under construction with Fred Moore on the left, while the lower photograph shows the gate today, still inviting visitors to the cemetery that David Petry, its biographer, calls "the best last place" in his book *The Best Last Place: A History of the Santa Barbara Cemetery*. (Above SBHM; below CONS.)

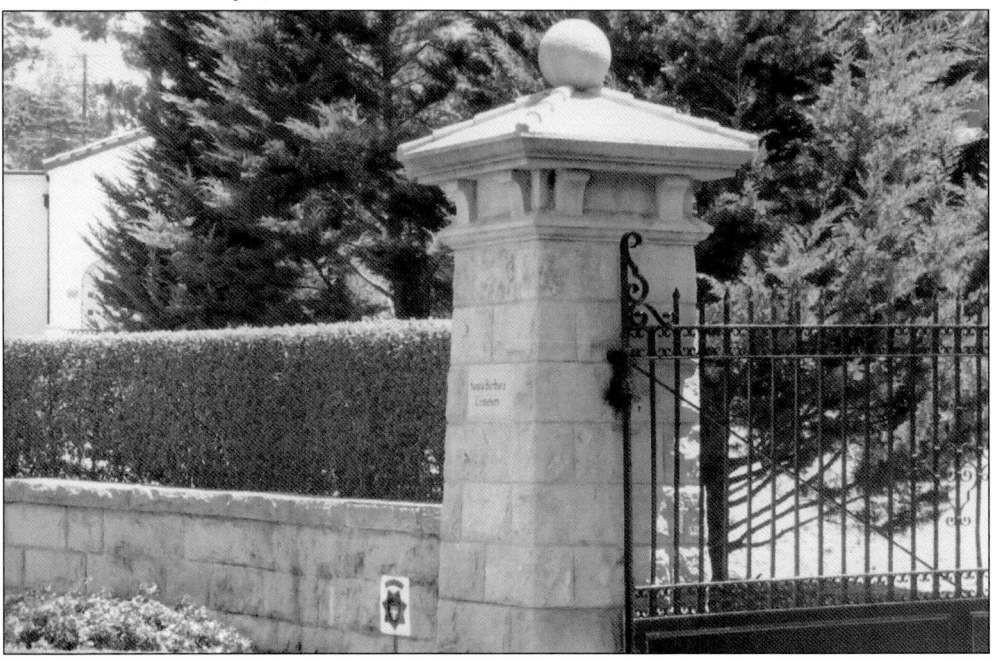

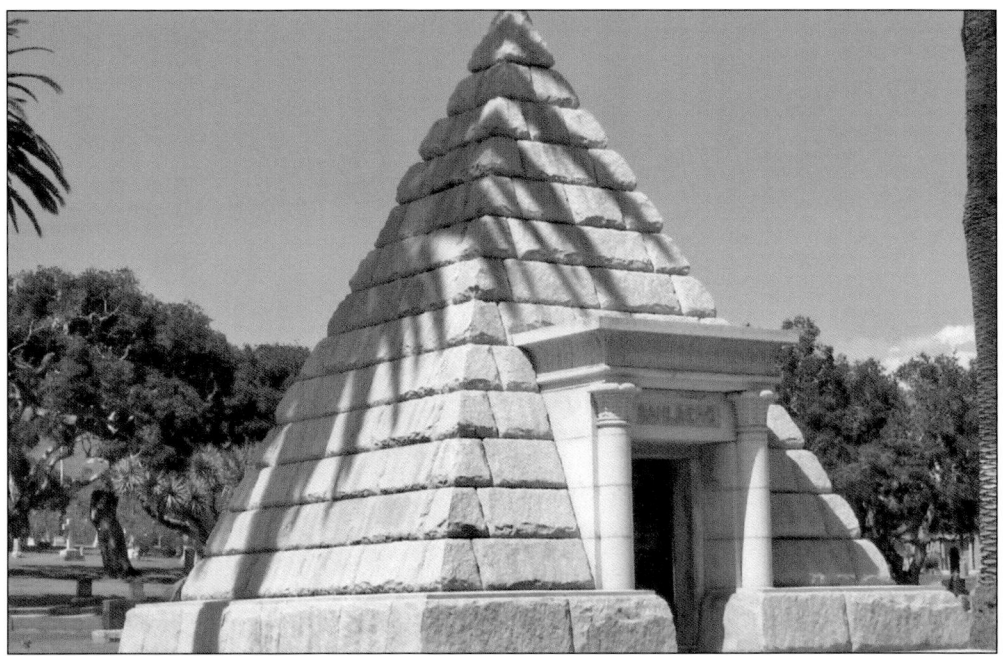

The era of mausoleum building hit the Santa Barbara Cemetery in the early years of the 20th century and, given the principal resource available, stonework became a hallmark. Among the first, and certainly the most unique, is this pyramid of white granite. It has its own peculiar history but nonetheless exhibits stonework of the first order. Erected in 1903, it looks as good now as when it was constructed. (CONS.)

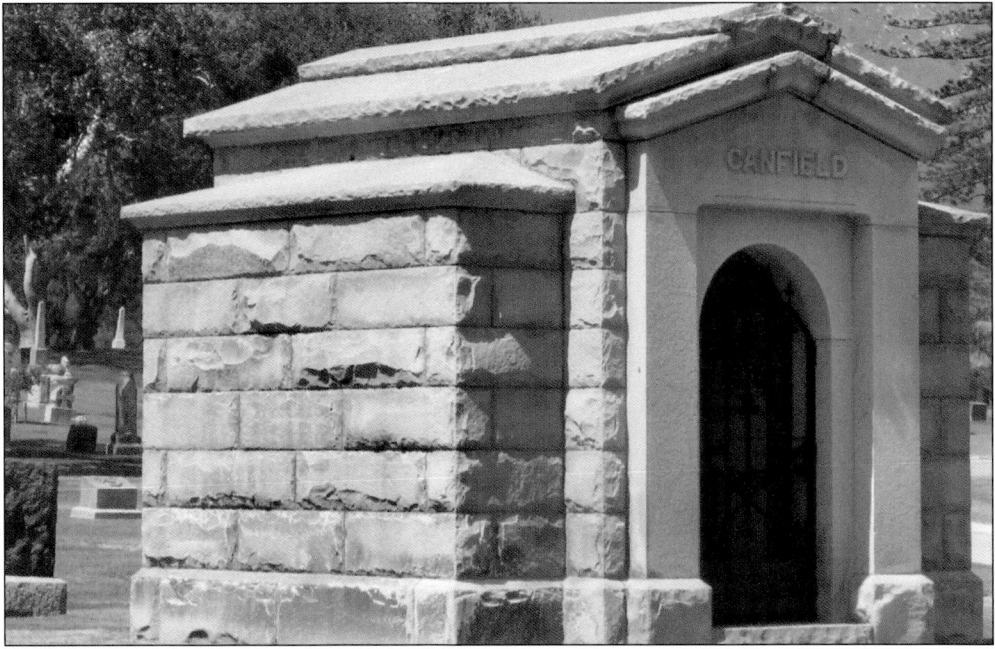

Another of the cemetery's mausoleums, this one is constructed of fine local stone. Note particularly the three stone slabs forming the main roof and the two pieces roofing the side extensions. Talented stonecutters can really do remarkable things with humble sandstone. (CONS.)

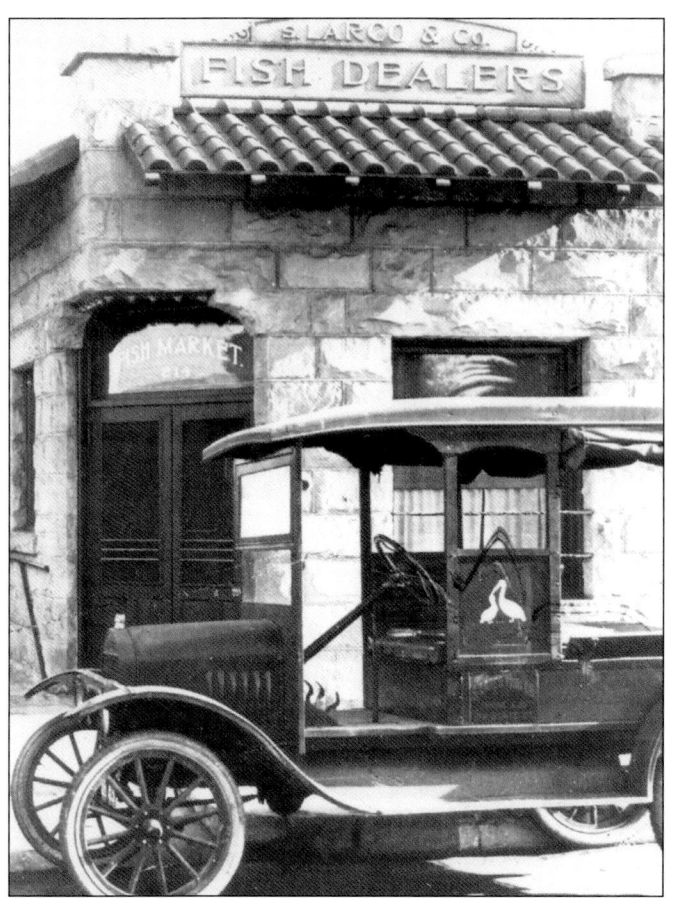

Perhaps the most prolific of the Santa Barbara builders in stone, the Scotsman Peter Poole produced a number of smaller structures around the city. Among them is the Larco Fish Market building, erected in 1911, which somehow manages to look petite despite the large stone construction. The building went through a number of iterations after the ownership of fisherman Sebastian Larco, and in the process, it became so beloved that the citizenry of Santa Barbara could not stand to see this wonderful reminder of another era demolished. Thus it was not only saved, but, in an expensive operation that demonstrated the worth of the past to the present, the building was moved to the waterfront, where it now serves as a visitor center. (Above SBHM; below CONS.)

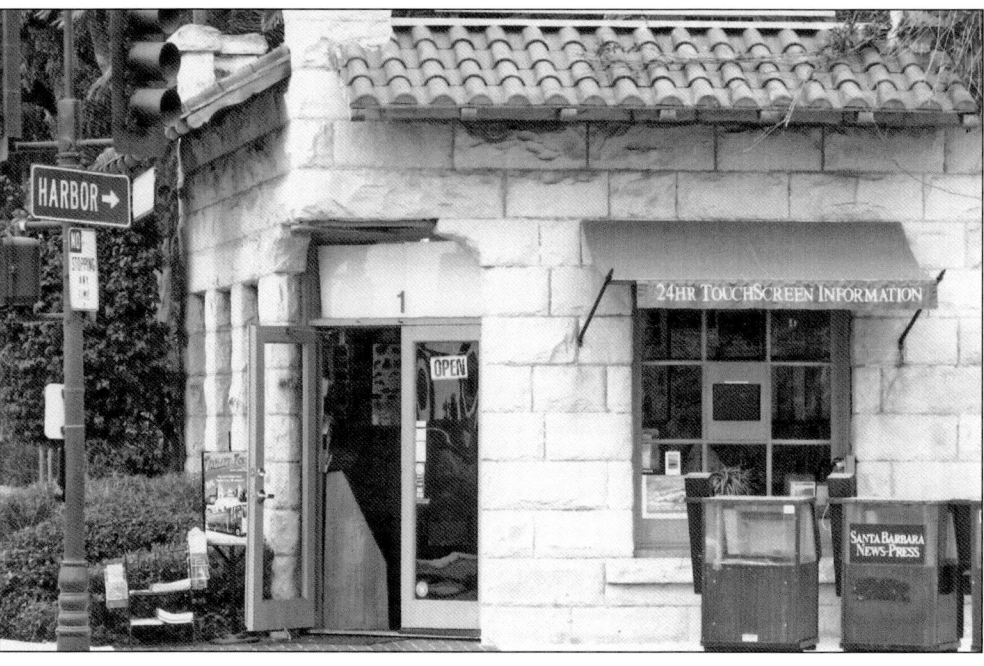

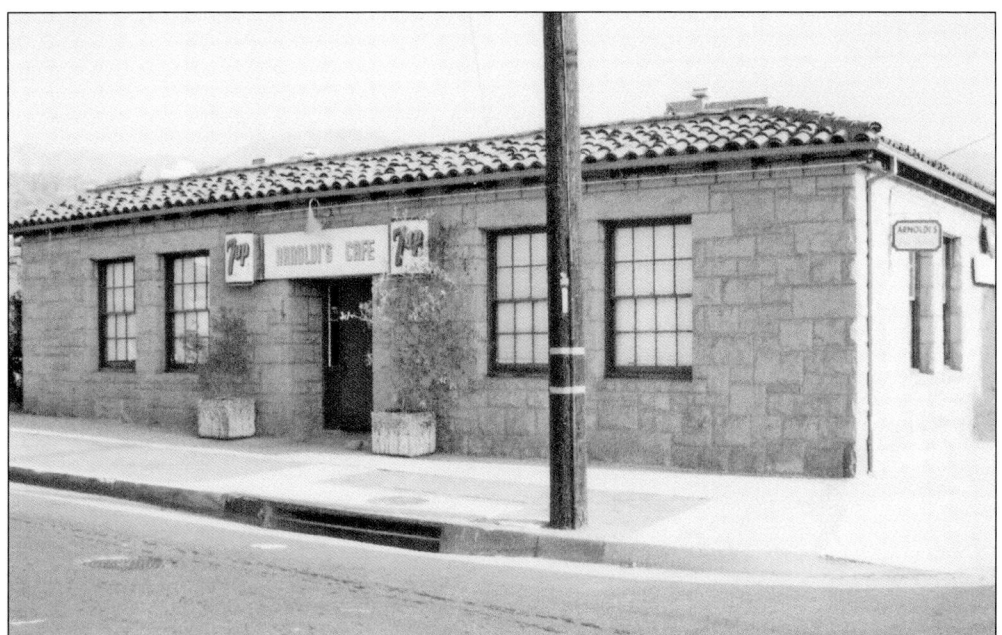

Joe Arnoldi, a stonemason from the Lake Como region in northern Italy, came to Santa Barbara in 1921 and began plying his trade. A year later, he brought over his fiancée, Ilda Gottardi, and the two were married. In 1936, Joe and Ilda leased a restaurant as a prelude to their own, which Joe built, of course, of stone. Joe and Ilda are now gone, but Arnoldi's Restaurant lives on, a Santa Barbara institution. (CONS.)

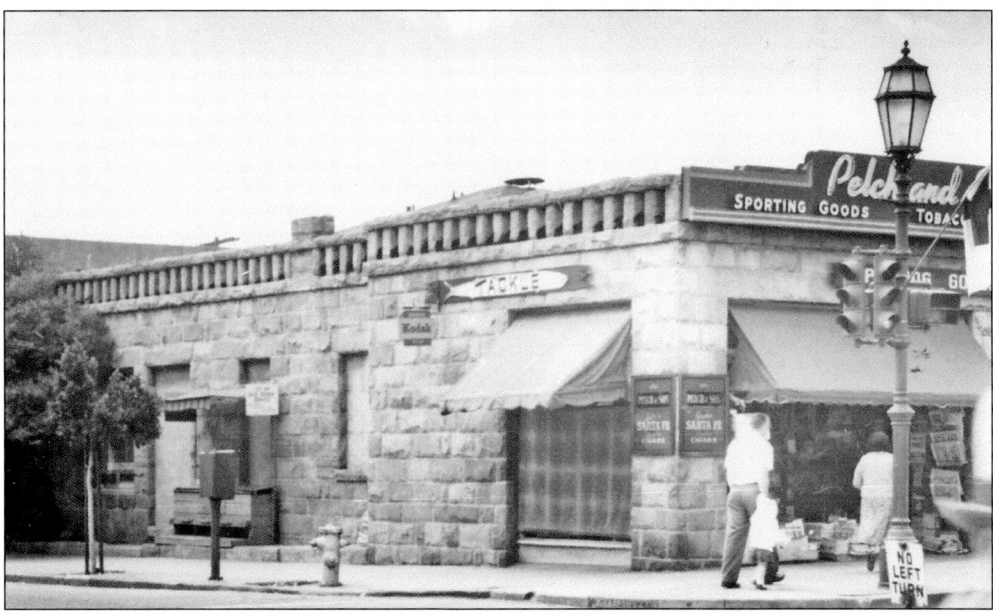

This fine stone edifice, which housed the Pelch family business for 44 years, was built at the corner of State and Anapamu Streets by Constance Ealand. It bears all the earmarks of a Peter Poole construction—small and nicely proportioned with special decorative effects, such as the altar rail along the top. Clearly both skill and care went into the creation of this now-gone example of the best in Santa Barbara stonework. (SBHM.)

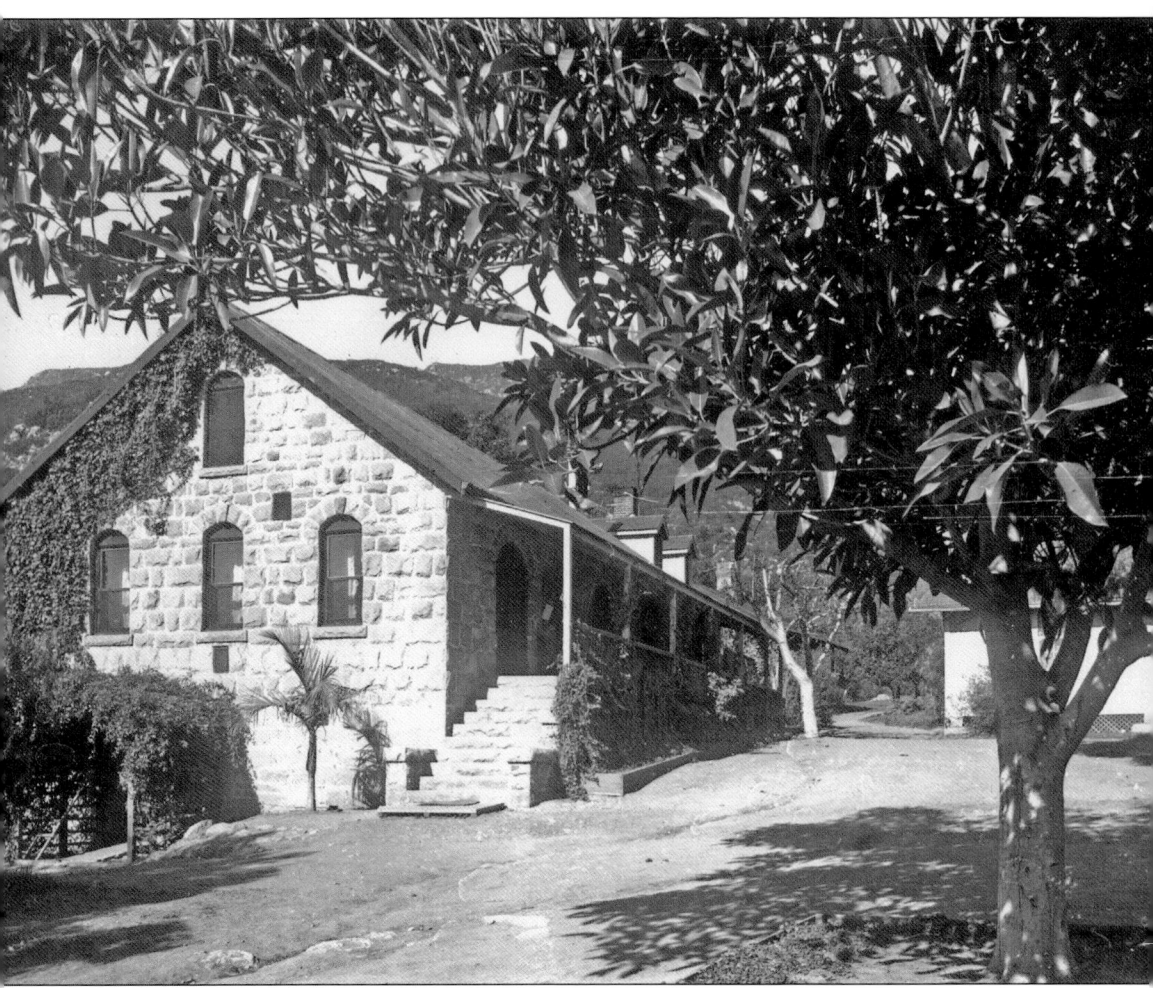

It is doubtful if honeymooners John F. and Jacqueline B. Kennedy were aware that the beautiful San Ysidro Ranch, where they were staying, had begun life as a grant from the Spanish government to a Presidio soldier in the 1780s. Nor did they probably know the ranch had once been a citrus operation. The most prosperous owners were John Harleigh Johnson and Taylor Goodrich, who purchased the property in 1883. After a fire destroyed their wooden packing plant, they built this classic stone structure. Johnson also built a small and highly successful hotel on the property that evolved over the years, catering to the world's greats, including Winston Churchill. Later owned by actor Ronald Colman and Alvin Weingand, it was discovered by the entertainment elite and has continued to burgeon. Through it all, the stone packing house remains, with the extraordinary Plough and Angel restaurant on the top floor and the Stone House Lounge beneath it, places where the Kennedys spent their first days together. Those early masons certainly constructed their buildings to last. (SBHM.)

One of the finest, almost modern examples of stonemasons on a big job took place at the 1952 restoration of the facade and towers at Mission Santa Barbara. Contractor Oswald Da Ros, son of Antonio Da Ros, whose distinctive masonry was so much a part of an earlier generation's contributions to Santa Barbara's stone building past, assembled an extraordinary crew of experienced masons. From left to right are Leon Grassi, Innocente (Joe) Buzzella, Louis Aquistapace, and Oswald J. Da Ros. Buzzella brought direct experience to the job. As a young man, he had been part of the large crew that had restored the mission's face after the 1925 earthquake. Da Ros established the stone yard directly in front of the mission and had quarried stone delivered there for finishing. It was a worthy task, and one the men accomplished with skill and respect. (Both, SBHM.)

While the use of pneumatic tools made the work go more quickly and easily, it was still the hand finishing techniques that made the work so personal and special, both to the mason and his audience. Here are stoneworkers in action. Note the carpenter's square on the partially cut block, an indication of the precise cuts made by these masters of the art. Below is the finished face of the "Queen of the Missions" after the restoration work of 1952. That facade still looks down the wide stone steps toward the city of Santa Barbara and the ocean beyond. Hopefully, thanks to the restorers, it always will. (Both, SBHM.)

Two

HOMES AND GARDENS
THE PERSONAL SIDE OF STONE

At the time Santa Barbara was beginning to grow and develop, the first stone structures appeared. They denoted a growing sense of permanence as the city was lightly brushed by what historians call the "Boom of the 80s" in the southern portion of California. A real estate bubble pushed by city builders and developers, the boom quickly faded, but Santa Barbara was little affected. Enough publicity had leaked out to the rest of the United States about the growing city by the sea and its benign Mediterranean climate to enable easterners to "discover" the place. As they came west seeking a place to vacation or escape the ravages of a Midwestern winter, Santa Barbara became an important destination. As these individuals joined the growing stream of ordinary citizens coming to Santa Barbara to experience the wonderful, year-round benefits of the region, they decided to settle permanently, often bringing their fortunes with them.

As they bought up land and planned great estates, these individuals recognized and appreciated the natural beauty of the area and seemingly had a reverence for the use of natural materials. Thus they joined the long tradition dating back to the first adobe structures in Santa Barbara and utilized local sandstone in building not only their homes but also outbuildings and, especially, garden features. They were not alone in their choice of building materials for homes, as others—some native, some newcomers—built stone homes ranging from large and imposing to the small, and, while not so consequential, nonetheless beautiful in their own right. Sandstone became a vital part of Santa Barbara's early emergence and provided the city with an unparalleled tradition of stone architecture.

With the availability of capital, raw materials, and, especially, a dedicated contingent of architects, builders, and masons devoted to the use of stone, Santa Barbara has been blessed by an abundance of stone houses and gardens, some examples of which appear here.

In 1912–1913, industrialist Clarence Black chose a site at the western end of Mission Ridge, just where it dropped steeply into Mission Canyon, to build the first major residence on the Riviera. In selecting that site, Black faced the challenge of a property littered with house-sized boulders. Black hired the best of Santa Barbara's stonemasons and turned them loose to build a portion of the residence, the water tower, walls, and the entrance gate designed by architect Roland Sauter. Upon completion, the entrance was deemed by the *Santa Barbara Morning Press* as "among the very best in Montecito and Santa Barbara," perhaps because, it was rumored, Black himself prowled the property selecting the stones to be used. Nine decades of vegetation obscures the original view, but the gate remains as a wonderful example of the mason's art. (Above SBHM; below CONS.)

At the time Black began his construction, there were no roads on the Riviera and thus no access to the estate. In addition to his duties in designing the gardens, architect Roland Sauter was given the task of laying out the three roads that bordered the property and engineering the walls that had to support them. It was then up to the masonry crew, which constituted a veritable United Nations of men and a who's who of Santa Barbara stonemasons—Joe Dover, Peter Poole, Antonio Da Ros, Joe Sacconaghi, Gottardo Calvi, John Antolini, and a host of others—to complete the work. More than two miles of stone walls were constructed before they were done. That it all still stands is a tribute to their competence and artistry. (Both, CONS.)

The rear or north side of the Black property dropped off severely into Mission Canyon and, nearly 100 feet below the crest of the ridge, Mountain Drive was cut into the hillside. There was great fear that, sparked by often heavy winter rains, erosion would eat away at the ridge and destroy the road. Sauter realized that a massive retaining wall would have to, as the newspaper put it, "climb and circle and writhe its way" up the drive for more than a mile. Four feet thick at the base and in places more than 20 feet high, this wall called for uncommon skill and workmanship as well as imaginative engineering. Sauter's creation has withstood Santa Barbara's numerous and sometimes severe earthquakes for almost a century with few signs of damage or deterioration. It is a testament to the stonemason's skill and the sensibility of building with stone. (Both, CONS.)

Architect and masons alike realized that the higher portions of the back wall would need additional support to withstand the potential push of the hill above. Sauter designed a series of strategically placed buttresses of an unusual triangular design into the 20-foot-high stretches of the structure to provide the needed strength for the wall. They obviously have worked well. (CONS.)

Here is a detail of one of the triangular buttresses. Note how the masons fitted the base into a stone footing and tapered the structure toward the top. Incorporating the buttresses into the wall and tying it all together took uncommon skill and patience, which this band of 20 to 30 men apparently had in abundance. (CONS.)

"One of the most elaborate and pretentious houses" in Santa Barbara is how the *Santa Barbara Morning Press* described El Nido (The Nest), built in 1897 by Charles Hopkins with architect Francis W. Wilson. The stones were brought in from Mission Canyon and left unsorted as to color to provide a richer appearance. In 1931, long after the death of her husband, Mrs. Hopkins chose architect Russel Ray to remodel the house. He wisely chose to retain the basic structure, only cutting down the tower to a more reasonable height to improve the overall look. El Nido has survived Santa Barbara's various earthquakes and has been lovingly cared for by its owners over the years. It remains an example of the efficacy of stone construction and the artistry of the stonemasons who put it together. (Above SBHM; below CONS.)

The charming Bingham house in Montecito is noteworthy not only for the excellent stonework characterizing its exterior but also for the fact that this 18-room residence was designed by the noted California architect Bernard Maybeck. In the Bingham house, Maybeck took advantage of Santa Barbara's stone-building tradition and a large cadre of superior masons to produce a permanent monument to the Bay Region style. (SBHM.)

Santa Barbara's Mission Canyon is littered with huge sandstone boulders that, in the hands of master stonecutters, became common building materials. The residence of prominent Santa Barbara citizen D. C. Williams stood at the west end of the canyon in the first decade of the 20th century. His home was a remarkable example of the mason's art. (SBHM.)

Over the winter of 1903–1904, Peter Poole took time out from his heavy construction schedule to build a seven-room sandstone cottage for himself and his family. Of a unique design, it contained a bathroom, pantry, and closets in addition to the seven rooms. Note the beautifully chiseled posts as well as the finely crafted altar rail fence/seat. Known as Hawthorn Den, it continues to grace Santa Barbara, testifying to the eternal attraction as well as the permanence of stone construction. (CONS.)

This unprepossessing stone cottage is a reminder of the days when Alamar Avenue was home to modest houses and auto courts. The low wall in front sets off a small yard paved with gravel, giving the place a decidedly desert look. Even so, it fits into a neighborhood of modest frame structures and remains unnoticed and unremarked despite its unique stonework. (CONS.)

On September 14, 1913, the *Santa Barbara Morning Press* noted the completion of "a handsome stone residence in a spot so secluded and sunny as to seem the very abode of pleasure and peace." This was Rockwood, home of Florence Weston. The magnificent stonework was the work of Montecito native John Arroqui, who fashioned the stones from boulders found in Mission Canyon. (SBHM.)

Charles F. Eaton brought his family to Santa Barbara in 1886, intending to build a stone house on his property. He hired a crew of masons and set them to work building a barn, perhaps as practice for the house. While the latter was never built, the barn was expanded, a second story of frame construction was added, and Riso Rivo was born. The stonework meshed perfectly with Eaton's wisteria vines. (SBHM.)

After selling his first home in Montecito, Charles F. Eaton, who still retained considerable acreage in the hills, built another residence, variously called Riso Rivo, Samiramis, or, more commonly, Eaton's Hunting Lodge. Situated high above Cold Spring Creek, it was a smaller structure than the original, although still two stories high, and Eaton again specified stone for his construction material. He chose a mellow, golden-hued sandstone that melded well with his usual beautiful landscaping. The photographs here are from a later period, after a new owner whitewashed the stone. While the color is harsh, it does bring out the interesting texture and exquisite detail of the exterior stonework. (Both, SBHM.)

A special feature of Eaton's Hunting Lodge was the fact that he utilized the thick sandstone exterior walls as unadorned interior walls as well. The rough-hewn, highly textured surface lent a unique ambience to the living room, with the stone fireplace in the corner as a central feature. Here the artistry in stone, so visible on the outside and in his landscaping, gave life to Eaton's living spaces as well. (SBHM.)

Even the master bedroom of Eaton's Hunting Lodge had sandstone walls, which gave the space a rustic yet elegant charm. While stone is often thought of as being cold, the golden glow of the original sandstone must have exuded a particular warmth for Eaton and his guests. (SBHM.)

Mission Canyon was both a source of building stones and a center of stone construction in Santa Barbara. One of the canyon's landmark homes is Glendessary, built by Robert Cameron Rogers in 1899. Rogers became the publisher of the *Santa Barbara Morning Press* and turned it into one of the best-edited dailies in California. His architect, Samuel Illsley, created an English Tudor mansion based on the kind of structure that had so impressed him the previous year while he was on his honeymoon in England. Christopher Tornoe, a skilled cabinetmaker and metalworker, was the builder, but even he had to make a bow to the boulders in the canyon by enlisting Peter Poole to create the imposing entrance and surrounding walls. (Both, SBHM.)

Peter Poole was also responsible for the masonry that distinguished the gardens of Glendessary, although his brother, Thomas, the longtime gardener for the estate, probably played a role in the design as well. The round stone fountain and stone planter facing the long, stone-lined walkway to the main entrance centered the garden directly in front of the house, while low stone walls edged the paths radiating from the fountain. A variety of other stone features, such as a pillared stone pergola, exhibited the fine textured stonework for which Poole was noted. The community is fortunate that so much of his work not only decorated early Santa Barbara, but also that a fair amount of it still lends its character to the aura that makes Santa Barbara the special place it is. (SBHM.)

Like a number of wealthy Easterners who sojourned in Santa Barbara at the end of the 19th and the beginning of the 20th centuries, David Gray fell in love with the community and its environs and decided to make his residence here. To that end, he purchased a 29-acre plot in the Montecito foothills and hired Roland Sauter to design a suitable residence, which he called Graholm, to be situated on a hill with magnificent views of mountains and coastline. Utilizing stone from the site and the availability of Santa Barbara's large number of skilled masons, Sauter not only managed to design and build a wonderfully permanent house and grounds but also completed Graholm within a year. Gray's residence remains and is now the headquarters of the Brooks Institute of Photography. (Both, SBHM.)

Santa Barbara's superb stonemasons included such prominent individuals as John Arroqui and Joe Arnoldi, who built an imposing entry gate to Graholm and created the sinuous stone wall lining the winding driveway up the hill. The beautifully proportioned design and the expertly cut stones combined to provide a dramatic entrance to this remarkable residence and the gardens that surrounded it. David Gray, like many of his contemporaries, became one of the city of Santa Barbara's most generous patrons, leaving a legacy that includes the Cabrillo Pavilion on East Beach. (Both, SBHM.)

In 1918, Mary E. Stewart, daughter of a Wisconsin lumber magnate, purchased a piece of property in Montecito, home to a charming stone cottage that she immediately cherished. It was integrated into the Il Brolino estate she proceeded to build, and the cottage eventually became, among other things, a garden house and an artist's studio. The cottage's most significant feature is the large alcove that dominates the interior and dwarfs the fireplace it contains. It is this uniqueness and the skill of the stonemasons who built it that make this attractive building a permanent part of the Santa Barbara scene. (Both, MHC.)

Designed and built in 1929, the striking structure known as Still Farm is a symphony of stone and a living monument to the talents of its stonemasons. Although the house suffered some abuse over the years at the hands of unappreciative owners, the most recent occupant embraced the unique stone construction and restored it to its original grandeur. It will continue to grace the Santa Barbara area for decades to come. (MHC.)

Noted architect Carleton Winslow Sr. designed Hacienda de Piedras for Jerome Chaffee in 1918. The wonderful stone structure, sometimes described as an elegant farmhouse or ivy-covered English cottage, was given life by stonemason Gottardo Calvi, a native of Italy. All of its owners have lovingly cared for the superb stonework, which still appears as fresh as it did when Calvi cut the blocks out of native boulders found on the property. (MHC.)

The striking Bellosguardo, which immediately became one of Santa Barbara's premier residences, was built in 1903 by Oklahoma oilman William Graham. The architect was the prominent Francis W. Wilson. Eventually marital difficulties and a resultant divorce caused Lee Eleanor Graham to sell Bellosguardo to flamboyant Montana senator William Andrews Clark in 1923. The senator died shortly thereafter, but his widow stayed on. In the midst of the Depression, she decided to build a new wing on Bellosguardo. She was so struck by the gratitude of the workers who thanked her profusely for the employment that she promptly tore down the old structure and built this magnificent stone house in order to keep them earning a paycheck. (Both, SBHM.)

The beginnings of the stone showcase known as Riven Rock occurred in 1896, when Owen Stafford sold his Rockland Farms to Nettie McCormick, the widow of Cyrus McCormick, inventor of the famed reaper. Mrs. McCormick built a substantial stone house on the property to serve as a residence for her son, Stanley, who suffered from a severe mental disorder. The Boston firm of Shepley, Rutan, and Coolidge designed the house, and local modifications were done by Santa Barbara architect Thomas Nixon. Most of the stone came from the quarry of Philip Henley, while Scotsman John Poole apparently did the house. Stone House, as it was called, stood until 1925, when it was badly damaged by the earthquake and dismantled. Its stones appeared later in several county road projects. (Both, SBHM.)

As soon as Nettie McCormick purchased the Riven Rock property from Owen Stafford, plans were put in motion for development. Local contractor Philip Henley was engaged to do the stonework for the property, and much of the stone used came from his quarry, which supplemented the stones on the grounds. Stafford's old house occupied the prime location on the grounds and so had to be moved to make room for the new place. To get to the construction site with heavy vehicles and equipment, Hot Springs Creek had to be bridged, so Henley constructed what came to be called Old Bridge. It was massive in nature, reflecting its use, but still featured a graceful arch across the creek. As the gardens were later created, Old Bridge was folded into the overall plan, with check dams and pools featured above and below the bridge. It is no longer extant. (MHC.)

The garage at Riven Rock was constructed at the same time the original Stone House was built, so at least some of the stone likely came from the quarry of Phil Henley. Much of it also came from the grounds where the massive boulders that covered the landscape were split, cut, and shaped to create the details apparent in this large structure. Such detailing took time and money, but the McCormicks demanded and appreciated the best in stonework. (MHC.)

The Pump House further exhibits the artistic abilities of the masons, even when erecting a purely functional structure. Note the evenly dressed blocks, the detailing around the windows, lintels, and sills, the diamond window in the wall, and the vent slots near the gable. Unfortunately, it has been impossible to ascertain those individuals who had a hand in it, although the list of those who worked on Riven Rock is a who's who of Santa Barbara–area masons. (MHC.)

When she purchased Rockland Farms, Nettie McCormick also obtained the water rights established for the property by Owen Stafford and had to develop her own water system. To the delight of the masons, that work was also done in stone. One of the large reservoirs shows off the watertight construction of which the stoneworkers were capable. Their sensitivity to the environment is also apparent. (MHC.)

The key element in the Riven Rock water system, as it was in all the private water systems operated in the foothills, was the water tower. As if to emphasize its importance, the masons of Riven Rock created a classic structure, one that still performs the function for which it was built. Round buildings require special skill and attention on the part of the builders but when done correctly make a remarkable statement about the beauty of stone. (MHC.)

To create the placid atmosphere of Riven Rock, the entire topography of the estate was reengineered, the courses of the creeks redirected, and the new channels partially dammed to create deep pools and the sound of falling water. High Bridge, often called Eucalyptus Bridge, had the distinction of having every employee on the estate select and lay a block during its construction. The extent and quality of the stonework is clearly evident. (MHC.)

Leaping Greyhound Bridge was one of the earliest built, perhaps by Fred Henderson, a prominent Santa Barbara stone contractor. He received a three-month contract for stonework in June 1899 and stayed for three years. This bridge exemplifies his imaginative use of local stones, as they all came from the property. The walls in the background indicate how intensively stoneworkers labored to beautify the grounds. (MHC.)

There evolved on Riven Rock a vast web of walking paths that led to every corner of the estate. These paths wandered through stands of oak and eucalyptus trees, crossed broad lawns, and circled hidden fountains but inevitably led back to one or more of the bridges that spanned Hot Springs Creek. Perhaps the most beautiful of those bridges is Camelback, which spanned the man-made Lotus Pool. While masonry construction is often thought of as massive in nature, in the hands of a true artist in stone, it can be light and graceful. Here the combination of rough and shaped stones provides a pleasing texture, while the keystone construction technique enables the flowing lines and long arch. Said G. Hart Tilton in his typescript "A Visit to Riven Rock, Stanley McCormick's Wooded Estate" Camelback "reminds you of the Camelback Bridge in the gardens of the Summer Palace in Peking." (MHC.)

Skew Bridge, third from the top of Hot Springs Creek, was the longest of the spans on Riven Rock and the most difficult to engineer. A special design was created incorporating nine individual arches, described by Gloria Calamar in her 1995 Riven Rock Bridges Landmark Proposal as "rhomboid in figure," and requiring especially accurate cutting and fitting. That made the span possible and gave it "a groined effect . . . in which their reflection is particularly charming." It no longer exists. (SBHM.)

In their ongoing effort to create an atmosphere of sensory stimulation, the master masons of Riven Rock developed the magical Bridgewood section of the estate in the upper reaches of Hot Springs Creek. Here Skew (top) and Leaping Greyhound appear among the oak and eucalyptus trees. Bridgewood, the most serene area of Riven Rock, clearly demonstrated the beauty that could be created with the appropriate use of stone. (SBHM.)

During the dark days of the Depression, Stanley McCormick provided employment for a number of local masons and stoneworkers through a continuous program of building walls and bridges to further beautify the grounds of Riven Rock. The two bridges shown here, Wisteria (top) and Ivy, are built so intimately into the environment that they seem always to have been a part of it. Only their arches, sharp and round, indicate that they are man-made and not part of the natural distribution of stones on the estate. Clearly the stoneworkers were as in love with Riven Rock as the owners, and their work here and in all the rest of the stonemasonry on the estate demonstrates it. (Both, SBHM.)

The story of Mira Vista, perhaps the first of the great Montecito estates, began in 1891 when a young health refugee from Philadelphia, Isaac G. Waterman, purchased a substantial piece of ground from F. A. Gallagher. Included on the property was a small two-story frame house into which Waterman and his new bride moved the following year. Both Watermans were prominent in local musical circles. They quickly built a separate music room of stone and, shortly thereafter, a two-story west wing, which became a center of entertainment for the whole community. The upper photograph shows the west wing in relation to the original frame house, while the lower one shows off the excellent masonry that marked its construction. The music room is to the right. (Both, SBHM.)

Mira Vista was a huge success and quickly became the showplace of Montecito. Waterman, however, suffered some serious setbacks, including a divorce in 1901 and subsequent financial difficulties that eventually forced him to sell in 1905. For the next several years, Mira Vista went through a series of owners before being purchased in 1913 by William G. and Mehitabel (Hettie) Henshaw. William Henshaw, who had made a fortune in Southern California real estate and for whom Lake Henshaw is named, wasted no time in developing a new Mira Vista. He hired San Francisco architect Albert W. Pattiani to remodel the residence. Pattiani eliminated the frame portion, expanded the stone wing to three stories, and matched it with a duplicate wing on the other side of the old music room, completing a beautifully symmetrical house. Construction began in March 1915 with a crew numbering between 60 and 70 men using stone quarried from nearby Montecito Creek. It was completed in an astonishing 10 weeks. (MHC.)

It is said that almost every stonemason in Santa Barbara worked at one time or another on Mira Vista. Among them were such notables as Clarence George, Peter Poole, and, between trips home to Italy, Joe Buzzella, as there was an enormous amount of stonework to do, and not just on the house. At the same time the residence was rising, a carriage house of a size to contain a dozen automobiles was also being built. On this two-story structure, the masons used the same amount of care—matching stones, arching windows and doors, and attending to the minutest of details—as they did on the house. Here too, the stone was quarried from Montecito Creek and shaped on the ground to provide a remarkable example of utilitarian stone architecture. (Both, MHC.)

In addition to the garage, the Henshaws ordered a gatehouse to be built at the Sycamore Canyon Road entrance to the estate. The ubiquitous Scotsman Peter Poole is reputed to be the builder. He took special pains to match the stones in this simple structure with those of the bridge balustrades, the pillars supporting the finely carved light standards, the gateposts, and the adjoining walls. That kind of detailed thinking elevated Mira Vista's stonework well above the ordinary. (MHC.)

One of the major stone features that remained from the Waterman era on Mira Vista was this wonderful altar rail fence separating the residence and its driveway approach from the classically terraced garden created by landscape architect Elizabeth B. Burton. Lovingly carved, with extraordinarily long rails, the fence offers proof of the huge boulders that were split, cut, and carved by the master masons. (SBHM.)

The post-Henshaw period in Mira Vista's history was a sad one, as the property, particularly the house, went through troubled times. At one point, the once-magnificent residence became the Westmont College dormitory Emerson Hall. The property was eventually split up and sold off, and the house, released by the college, languished without care and became a neighborhood eyesore. There were calls to tear it down. In 1993, the Gale family purchased the house, by then a complete shambles, and took stock. Recognizing the underlying structure for the jewel it was, the Gales completely and meticulously restored the grande dame to its former glory. Mira Vista remains a monument to Montecito's past and a tribute to the master builders who created a true marvel in stone. (Both, MHC.)

It is often said that the devil is in the details, but in the case of the perfection that is Mira Vista, it is the details that make the building. Note the exquisite detail in the corbels shown here, under the wooden balcony, and particularly under the flat stones extending over the wall. The masons obviously loved their work and had the freedom to express it. (MHC.)

When using stone, masons usually carve names, house numbers, and the like by incising the blocks. But on Mira Vista, in keeping with its unique stonework, the entrance gate is carved in relief—a most difficult task, as one wrong stroke can destroy a letter. Even the entrance to Mira Vista emphasizes the exquisite stonework that distinguishes the place. (CONS.)

Three

INFRASTRUCTURE
BRIDGES AND WALLS

Among the most apparent expressions of the beauty in stone that give the region such distinction are bridges and walls, the former necessary to the operations of society, the latter a ubiquitous means of delineating boundaries, holding back hills, and supporting roads. These seemingly mundane constructions, while serving their functional purposes, also offer the eye an often surprising and always pleasing bit of artistry.

Situated on a narrow strip of land between the rugged Santa Ynez Mountains to the north and the Pacific Ocean on the south, the Santa Barbara area is cut through by a number of creeks and their canyons, which drain the mountains to the sea. All east-west roads are forced to span these sometimes steep canyons and always volatile streams, dry during the summer but occasionally raging torrents in the winter rainy season, and these crossings demand seriously engineered bridges. Local masons were imbued with the tradition of the arch, the constructive power of which liberated stoneworkers from the constriction of post and lintel and made possible the amazing aqueducts of Spain, the beautiful bridges of the Alps, and the soaring ceilings of the cathedrals of Europe. They translated that capability to local construction with extraordinary results, some of which appear herein.

They did no less with the construction of the miles of walls snaking across the foothills and flatlands of the city and its environs. While walls usually require far less in the way of engineering than bridges, they offer more opportunity for stonemasons to express themselves and their artistry in the selection, carving, and setting of stones. Coming from a diversity of nationalities and backgrounds, Santa Barbara masons have taken advantage of the opportunity to display a variety of styles and approaches. In doing so, they have created and maintained a high standard for excellence in stonework, one which has lasted for more than a century. It is a model whose limits are constantly extended and which will continue to be advanced for the foreseeable future.

While it is generally the large stone buildings—churches, banks, and the like—that provoke the admiration of those who see and appreciate them, occasionally a stone bridge can elicit a feeling of awe in a viewer. Such is the case with this structure, high up steep and flood-prone Romero Canyon. It provides access to the San Carlos Ranch and elicits a remarkable sense of amazement at the skills and capabilities of Santa Barbara's stonemasons. The stones are large, well cut, and deftly placed, and the abutments are angled to blunt the force of the water. The arch itself is the dramatic centerpiece, drawing both attention and admiration. The bridge is a classic and will continue to grace the canyon for years to come, adding its bit to the stone culture of Santa Barbara. (Both, CONS.)

While he was completing the various walls, terraces, and gateposts on the Hazard property next to the mission, mason Joe Dover was prevailed upon by Rowland Hazard to construct a bridge over Mission Creek that would connect the mission and the city of Santa Barbara to upper Mission Canyon and open a foothill route to the Goleta Valley. That magnificent structure, described by the California Department of Transportation in *Historic Highway Bridges of California* as "the oldest extant bridge in Santa Barbara County" and one of the oldest in the state, was completed in 1891. It still stands and funnels thousands of cars into and out of the city daily. Dover's intricate stonework is a glorious example not only of the mason's art but also of the useful permanence of stone construction. The bridge has stood against earthquakes, floods, and the constant pounding of trucks and cars for well over 100 years and bids fair to last at least 100 more. (Both, SBHM.)

This handsome span vaulting Cold Spring Creek on Ashley Road was constructed by John Arroqui in the early years of the 20th century, at the same time the McCormick family was developing the Riven Rock estate in the same watershed. It stood its ground against the occasional floods until 1960, when the County of Santa Barbara, fearing excessive damage from a then-raging flood, bulldozed the stone parapets of the bridge. Afterwards the county replaced them with temporary wooden barriers and announced its intention to install an ugly steel railing on the bridge, but public outcry over the destruction of a cherished landmark halted county plans. (Above CONS; below MHC.)

The Montecito Association Roads Committee mounted a fund-raising campaign to restore the stone parapets. The effort languished for a decade before public-spirited citizen Joseph Masin donated the needed funds and master mason Brad Bartholomay offered to do the work for minimal compensation. The meticulous restoration work was finally completed in 1983, and a signal piece of stonework continues to add beauty to the area. (CONS.)

This bridge spanning the steep canyon of Sycamore Creek is on Stanwood Drive at Parma Park. Built to withstand the occasional floods that rip down the canyon, the lower portion of the bridge up to the top of the arch is solidly built with large, square-cut stones. The parapets above are constructed of rounded stream rocks, while the flat, cut stone cap, which sticks out from the wall, tends to make for safer drivers—otherwise the cap will decorate the side of the car. (CONS.)

Among the most charming bridges in Montecito is this one on El Rancho Road at its junction with Camino Viejo. The stone understructure features a rectangular opening, not the most efficient in terms of moving floodwater through, but the bridge's most interesting features are the parapets bordering the roadway. Strong posts at either end bracket a heavy altar rail fence protecting motorists from dropping into the normally dry creek bed. The rail posts, 1.5-foot square and 2 feet high, are unusual in that instead of being solid blocks of stone, they are composed of fitted and mortared cut stones. This bridge was erected by stonemasons with a sense of beauty. (Both, CONS.)

Santa Barbara's front country is cut by a number of small creeks, some with fairly deep canyons, which are normally dry except during brief periods of winter rains. Any or all of them can present serious flooding problems in exceptionally wet years or as the result of rare thunderstorms. All east-west roads, therefore, require substantial bridges at each crossing, and stone proved to be the building material of choice, as it provided permanence and beauty and, of course, was readily available. This keystone arch is perhaps the most graceful of the lot, spanning Romero Creek, its sweeping curve terminating in interesting end posts. (Both, CONS.)

Just after climbing out of Mission Canyon, Las Canoas Road crosses the steep, deep arroyo of Lang's Creek. It rides on an old stone bridge, the walls of which brace a high stone arch over the normally dry creek bed. The bridge has occasionally been repaired over the years as rare freshets have caused damage, the work usually done without regard for the original construction. The rounded stone walls that line the road atop the bridge have likewise been patched, as drivers sometimes have difficulty navigating the sharp turn across the chasm, but the bridge still stands as a testament to the quality of early stone construction. (CONS.)

One of Peter Poole's more significant contributions to Santa Barbara's stonework was the construction of the bridge on Las Canoas Road over Rattlesnake Creek. It opened a new road connection between Mission Canyon on the west and Sycamore Canyon on the east and also provided access for the city's expansion into Santa Barbara's backcountry. Supervisor Sam Stanwood suggested—or perhaps insisted—that the bridge be built of rounded stream stones to better harmonize with the environment. Although Rattlesnake Creek has been subject to numerous floods over time, the bridge still stands solidly over the creek above Scofield Park. This plaque, mounted on the bridge, indicates its importance. The "designor," Owen O'Neill, became one of Santa Barbara's first historians. (Both, CONS.)

Peter Poole put a unique signature on the Rattlesnake Canyon Bridge by placing large, rounded rocks, in keeping with the bridge's theme, on the top of the end posts. That they still remain in place is a mark of the respect Santa Barbarans maintain for their stone infrastructure. (CONS.)

Peter Poole's parapet and posts contrast sharply with this less environmentally oriented but much more efficient and straightforward bridge parapet on Ramona Lane. Still the latter has its own formal beauty and certainly exhibits the stonecutting ability and construction skills of its builders. It also adds a touch of time-gone-by to the area. (CONS.)

Charming bridges mark the wanderings of the many small creeks that course through Montecito and, in many cases, stonework adorns the parapets. Even on these short, basic concrete spans over Oak Creek, the parapets are heavy, carved stone. The upper one, on Hixon Road, is unusual because of the substantial stone buttresses, clearly there for aesthetic purposes rather than essential support. The lower bridge, around the corner on San Leandro Lane, again a basic cement structure, sports a lighter stone parapet with three small buttresses adding interest. There is speculation that the stones for these particular bridges came from the original Riven Rock residence. (Both, CONS.)

In 1907, Clinton B. Hale began a massive stone construction job that included an outsize residence, an equally large barn, and a 6-foot-high wall surrounding his property just below Mission Santa Barbara. According to the *Santa Barbara Morning Press*, he employed "15 stonecutters and masons alone, under the direction of contractor [Fred] Henderson." The newspaper further provided an insight into the method and a comment on the dangers associated with stonework when it reported, "the site upon which all this work is being done originally was covered with immense boulders. The modus operandi has been to mine underneath the sandstone mass, lay a huge charge of powder, and then get out from under. One immense boulder lifted in this manner measures 20 by 20 feet in diameter, and was in the earth fully 15 feet. A keg and a half of giant and black powder was used to loosen the giant boulder." Unfortunately, all that remains of this project is a large portion of the 6-foot-high stone wall stretching for a block along East Pedregosa Street. (CONS.)

Where the wall turned south at the corner of Mission Street, the masons changed their approach to laying up the structure. On Pedregosa Street, the blocks were a uniform 12 inches in height, though the lengths of the blocks varied from 1 foot to almost 3 feet, and the grout lines remained straight and parallel to the ground. But along Mission Street, the lay up turned random, giving the texture of the wall a totally different look, with only the capstones tying together the two sections of wall. Whether working on either type of wall, the masons did not neglect the details. The lower photograph is of a gate in the Mission Street wall. Note the clean lines on either side of the opening and the massive lintel tying the sides together. Though the wall is over 100 years old, it looks almost new and certainly adds grace and charm to the neighborhood. (Both, CONS.)

This long, high, sinuous wall, which stretches from Mission Santa Barbara along East Los Olivos Street, was built by Joe Dover in 1890 under contract to the mission fathers. Dover, the son of a seafarer who settled here in 1850, was born in 1861 and chose to follow in his father's footsteps when he joined the navy at age 17. He contracted malaria on one of his voyages, left the navy, and, to the city's eternal benefit, returned to Santa Barbara in the 1880s. Here he learned the masons' trade and, within a decade, was well enough established to earn the mission contract. This wall, now well over 100 years old, still graces East Los Olivos Street and the mission, the only change made over the years being the addition of buttresses to help protect against earthquake damage. (Above SBHM; below CONS.)

Rowland Hazard, the 1890 owner of the property on Mission Hill between the mission and Mission Creek, had some experience in stonework back on the East Coast. When he saw Joe Dover building a massive stone wall extending from the mission along East Los Olivos Street, he immediately recognized Dover's genius. He obtained permission from the fathers to have Dover extend the wall to the Hazard property and then turned him loose to build stone walls on the Hazard land. Starting with two massive round gateposts with conical tops, Dover swept his wall along the curve of the road toward Mission Creek utilizing rectangular cut blocks in regular level rows. Most of the raw materials came from nearby Mission Canyon, which is still littered with massive boulders, and were cut and shaped on the ground. (Both, CONS.)

When Dover reached Mission Creek, he finished the road portion of the wall with this pedestrian entrance to the property. Two square posts with Dover's signature pyramidal stone tops and a pair of stone steps, one a single stone, frame the opening for the wooden gateposts, wooden altar rail top, and arched gateway. (CONS.)

Those who visit the mission and venture to look at the walls extending north along East Los Olivos Street will note that the walls Joe Dover built for Rowland Hazard now have four buttresses bracing a section near the original entrance. There was fear that the wall in that area might be shoved over by moving dirt, so the additions, matching the original work, were made. (CONS.)

After the completion of the Mission Canyon Bridge, Hazard and Dover conspired to create what remains the most unusual wall in Santa Barbara. Hazard owned the property on the north side of Mission Creek between the creek and Puesta del Sol Road, and he proposed building a wall several hundred feet long fronting that road of a special construction that, as written in the article, "Olden Days," in the *Santa Barbara News-Press*, "would not appear out of place on one of the old estates in one of the Shires of England." Dover began the wall at the end post (with its pyramidal cap) of the bridge and swept it around the corner into a cylindrical gatepost. Putting in another gatepost on the other side of an entrance driveway, he continued the wall around the corner and down Puesta del Sol Road. (Both, CONS.)

Purposely using a rougher cut on his stones and throwing dirt into the mortared joints to promote moss growth, Dover strove to make the wall appear as though it had been there for centuries. The most singular thing about the wall was the backbone of triangular stone fins with which he capped it. It was described by an observer as a "stegosaurus wall" in an article in the *Santa Barbara News-Press*. Another contemporary commented in the same article: "Much of the beauty of ancient buildings . . . comes from the softening of the lines by the action of the elements, and the builders of the wall in Mission Canyon—owner and mason, conspired with nature to gain just this desired effect." The wall itself, now well over 100 years old, has acquired its own aura of authenticity. Behind it now stands the Santa Barbara Museum of Natural History, whose modern visitors still marvel at this "ancient" wall. (Both, CONS.)

The juxtaposition of these two random ashlar walls at the junction of Lasuen, Paterna, and Moreno Roads clearly illustrates the difference in approaches in two separate eras of stone construction: modern road building (above), and the original stonework done for George Batchelder as he opened the Riviera to residences. On the one hand is a hastily thrown-together wall with little shaping of the stones, a mixed bag of colors, lots of mortar to hold it together, and no cap. It is quite functional but adds little to the ambience of the area. The old wall, on the other hand, is uniform in color, with carefully cut and fitted stones, no mortar, and a heavy, decorative cap. One is immediately struck by the extraordinary craftsmanship, the obvious pride that went into its construction, and its contribution to the general beauty of the area. It, too, performs its function as it has for nearly 100 years. (Both, CONS.)

When George Batchelder created the Riviera Corporation and began the development of the Riviera, he intended to provide every building lot with a view of the city and ocean. This meant laying out roads in irregular patterns and made for complicated crossings. That did not stop him from adding beauty to the mundane. Here, at the intersection of Paterna and Lasuen Roads, are two original light standards. Though they are both cylindrical, they appear to have been done by different masons. One looks like the work of Joe Dover, who did much for Batchelder on the ridge, but practically every stonemason in Santa Barbara worked on the Riviera walls and other constructions. The miracle is that in nearly 100 years, they have not been taken out by a careless motorist. (Both, CONS.)

In developing the Riviera, George Batchelder put his road builders in a difficult position. They were required to lay out streets to provide each lot with a view, but the steep face of the Riviera made it nearly impossible to put some of the roads where they needed to be. One of the solutions devised, made possible by the stonemasons on the job, was to divide opposing lanes with stone walls, as here on Grand Avenue. (CONS.)

These walls, on a steeper section along the face of the Riviera, show both how necessary walls were to the development of the area and how beautifully they complemented the neighborhood. The lower wall divides the two lanes of Alameda Padre Serra, while the wall immediately above borders the street. Successive walls, in various styles, give the property owner some flat areas to work with below the residence, which is out of sight above. (CONS.)

The hill above Grand Avenue is especially steep at the western end and required substantial walls to hold back the soil. This tall and stately structure, oddly buttressed, features dramatically raised grout, which serves to beautify as well as protect the land and house above. (CONS.)

This graceful arch in the same wall on Grand Avenue frames a set of stone steps leading to the residence above. The arch theme is carried on in the two-car garage, a corner of which appears on the left. Such careful stonework is common on the Riviera, as it is throughout the Santa Barbara area, and has served to distinguish several neighborhoods as well as the region as a whole. (CONS.)

This anomalous construction, a small wall enclosing stone steps leading steeply upward to a path across the hill, stands near the west end of Alameda Padre Serra as it turns sharply around the end of Mission Ridge. The steps once gave access to the original streetcar line that snaked up the hill from the mission toward the site that would become the Santa Barbara Normal School, completed in 1913. It remains an interesting vestige of the past. (CONS.)

This is a section of the original wall that held back Mission Ridge above the streetcar right-of-way. While it is a rather rough-looking wall, it continues to serve its purpose with regard to Alameda Padre Serra. Note the massive boulder on the hill above the wall. It is representative of the thousands that once littered Mission Ridge and were carved up to make the walls of the Riviera. (CONS.)

These examples on Paterna Road represent the miles of beautiful stone altar rail fence lining the roads of the Riviera, as well as other areas throughout the Santa Barbara region. They served a practical need as well as a decorative function by keeping errant horses and buggies, and later automobiles, from potentially slipping off the steep drops on the downhill sides of the streets. While the rails showed only about 3 feet high from the road, the fences stood atop substantial walls, some as tall as 20 feet. They have maintained their functions well over the nearly 100 years of their existence, and local residents have not only maintained the original stones but have continued to add to the stone decor. (Both, CONS.)

The massive altar rail fences served what might be termed normal fence purposes as well. Here one delineates an off-street parking area and connects to a major residential wall at the far end. While the two structures are dramatically different in style and purpose, they seem to blend seamlessly into a single whole, due no doubt to the appealing presence of Santa Barbara sandstone. (Both, CONS.)

Though it is difficult to imagine stone blocks weighing hundreds of pounds, however nicely carved, looking graceful, the altar rail fences of the Riviera do just that. Among the reasons are the special touches added by the European-trained stonemasons, touches like the gently curving end stones, which soften the solid, square look of the fences. (CONS.)

This sweeping curve protecting drivers along Paterna Road from the steep drop-off is a perfect example of the elegant altar rail fencing that adds such distinction to many neighborhoods on the Riviera and elsewhere. (CONS.)

Pedestrian entrances to the houses situated on the lower sides of Riviera streets often show nothing behind them because of the steep drop-offs, often 20 feet or more, but all reflect differing uses of stone. The upper photograph shows a simple setback in an altar rail fence along the street and frames a stone stairway leading down. It is done with extreme care. The other is a simple pair of stone pillars framing a stone stairway leading directly down and supporting ornate wrought iron lamps. Somehow stone, in whatever shape, makes an inviting entrance. (Both, CONS.)

The stately pedestrian entrance to the old Taynayan Estate, with a stone wall immediately inside to guide people along the proper path to the residence, still looks outward along upper Garden Street. The almost delicate, well-capped posts, with the name carved directly into the stone, are reflective of a style once common to the region and offer a touch of beauty to the mission area. (CONS.)

Garden openings in walls facing city streets were common in an older Santa Barbara. This one, coming almost at the end of a wall, has a charming keystone arch over a rustic door and recalls a more genteel era in the city's history. (CONS.)

This ponderous wall on upper Garden Street, with its heavy cap and equally heavy foot, follows the up-and-down contours of the land and the street beside it; however, the masons decided to keep their grout lines level. This made for a technically difficult wall to build, requiring no small amount of skill to keep the constantly changing angle correct, but certainly made for an interesting piece of masonry. (Both, CONS.)

Santa Barbara's stonemasons saw beauty in a variety of styles. Unlike the heavy wall above, here large, rough stones, carefully chosen and placed for dramatic effect, form a rugged six-foot structure fronting a property whose residence sits high above the street. The construction of such a wall takes special skill in terms of picking out appropriate stones to minimize shaping while fitting well enough to maintain structural integrity.

This wall, with the walled terraces above, is said to be the work of the Italian stonemason Atilio Bazzi. He worked in the same style as the others in the neighborhood, although using smaller stones in a variety of colors. Two sets of stone steps, one narrow and one wide, lead pedestrians through the terraced gardens to the residence. Advantages of this kind of stone are the minimum need for maintenance and the timeless beauty that seems to improve with age. (CONS.)

This neatly kept, well-maintained wall and gatepost on Padre Street show off the work of a gifted stonecutter in the finely carved cap on the post. The three layers with a ball on top reflect the work of a man who cared about beauty and perfection and produced them. (CONS.)

Junipero Plaza, just below Mission Santa Barbara, is a stone fancier's delight. Several of the houses along this one-block street have utilized stonework for their sidewalk fronts in keeping with the stone gates at either end. Here are two fine examples of stone-framed entrances done in different styles. The upper photograph displays a heavy stone wall with formal cap and posts with nicely carved balls on top of them. The lower photograph shows a lesser, lighter wall with no cap, a mounted iron gate, and two finely carved florals atop the posts. Both make inviting ingresses. (Both, CONS.)

Building walls in the hills of Santa Barbara and Montecito posed some serious challenges to those early stonemasons. Blocks were generally cut to the maximum size that a gang of men could handle; moving them to a work site and setting the courses involved enormous labor. The only advantage that sometimes applied was the presence of raw materials on the site, but much stone was obtained from local quarries and carted to job sites. In the case of the lower photograph, masons had to devise a rail system to enable them to conquer a steep hill while maintaining the level of their courses—no small feat! (Both, SBHM.)

As C. H. "Pete" Jackson was opening his San Carlos Ranch along East Valley Road in Montecito, some of Santa Barbara's best stonemasons, including such luminaries as Joe Buzzella and the Arnoldi brothers, were given the freedom to create both walls and buildings. On the ocean side of East Valley Road near Jackson's polo grounds, there remain several sections of what once was a long, continuous wall. Now broken by entrances for new development, the old wall remains too beautiful to eliminate entirely. The stones are well cut and fitted in random fashion without the use of mortar. The cap sets this wall apart from all others, with the curved stones leading to the top of the posts giving it an unusual grace. (Both, CONS.)

Among the many entrances to Christian R. Holmes's Feather Hill Ranch, this sweeping stone gate utilizes round stream rock rather than the cut stone used elsewhere. It provides a distinctive entrance, appearing to embrace those who approach and welcome them in. The well-chosen, well-laid stones add to the effect. (SBHM.)

Among the many walls in the Montecito area, those along Parra Grande Lane especially evoke a sense of the region as it was in the early part of the 20th century. Here is an unusual formal wall built as the border of an estate. It features sharply cut, dense stones, raised grout, and a stone walkway integrated into the wall itself, a nice feature as the wall borders the road for hundreds of feet. (CONS.)

While long lengths of stone wall can sometimes be boring, the original builders along Parra Grande Lane broke up their extensive reach of stone by incorporating massive planters into the construction of the wall itself. It is an excellent decorative feature and defines a special wall around a special property. (CONS.)

Directly across from the planter wall is a contrasting modern treatment of a stone entrance to a residence. Using smaller, more colorful stream rocks set in mortar, these walls and gateposts make a most inviting and not overwhelming approach. (CONS.)

Although there are an almost uncountable number of outstanding walls throughout the region, this one, at the corner of Riven Rock Road and East Mountain Drive, exhibits a standard of excellence hard to beat. Using smaller, relatively smooth stones (as opposed to the larger, "pitch face" blocks more commonly seen), cutting and fitting them with exquisite skill and care without the benefit of mortar, and with a minimum of chinking, some true artist in stone created a work of arresting beauty. Instead of simply finishing off a corner with a post at the junction of two walls, he produced two posts and a curved section in between, a unique and special feature. He continued the same work on the adjoining walls, with the top stones so well fitted that they need no cap. (Both, CONS.)

This modern approach to decorative stonework is more a screen than a wall, at least in the sense of the stone walls featured in this book. Tall and thin rather than thick and solid, it nonetheless serves its purpose in shielding the residence behind and certainly is a striking sight along the road. (CONS.)

This little gem of a wall frames the beautiful grounds of the Oak Knoll estate along East Valley Road. Built from stream rocks more or less graduated in size from bottom to top and curved to match the border of the road, the wall features a gatepost with a wide stone cap nicely carved with the name of the property. (CONS.)

The torch—or perhaps it was a chisel—was passed to the newest generation of master masons in 1983, when four Mexican artists in stone erected this wall on Picacho Lane. Building in a more modern style using smaller stones with smoother faces, an apparently random though meticulously fitted body of stones, and no formal cap, these skilled masons put together a masterpiece. Justifiably proud of their accomplishment, they mounted a plaque in the wall, signifying their creation and making a place for themselves in the pantheon of Santa Barbara's master stonemasons. In building a wall for the ages, they set a high standard for all those who will follow in the Santa Barbara tradition of stone architecture. (Both, CONS.)

Four

ODDMENTS
INTERESTING USES OF STONE

In putting together this volume, the authors ran across several pieces of stonework, or even stones themselves, that did not fit easily into a particular category. Although some similar items appear in the Homes and Gardens chapter—water towers, pump houses, and the like—they are attached to a specific estate. The oddments here stand alone as unique or have special stories of their own. Remarkably, the stonework exhibited here is the equal of any of that lavished on the most expensive mansion or public building. Stonemasons, whatever they are challenged to build, inevitably attempt to create a work of art. It is, of course, the stone that demands the best from the mason, and it is the mason who undertakes to understand what one man called "the language of the stone." When one understands that language and can translate it through imagination and the magic of his hands into a finished product, he provides us all with an enduring legacy in stone.

Stonemasonry is one of the more difficult trades. Not only does the mason have to be physically strong to handle the weighty stones—think of the various heavy walls pictured in this volume, composed of stones weighing several hundred pounds each, while contemplating the crushed and bruised fingers that attended the hoisting and setting of those stones—but he also has to be well schooled in mathematics, particularly geometry. Think of the mason imagining how the stones will fit together in those exquisite walls that feature variously sized and placed stones, carved to fit so tightly they need no mortar. While mentally measuring the angles necessary for the fit, the mason chisels away, knowing that with one wrong tap the stone could be ruined. It is not a task for the faint of heart.

But what all those Santa Barbara stonemasons, known and unknown, have left is a permanent legacy of beauty and distinction, one in which the community takes pride, and that, with each new generation of masons, continues to expand.

This wonderful stone structure was once the gatehouse to the sprawling Cima del Mundo estate of Lora J. Knight. Mrs. Knight and her husband were early supporters of Charles Lindbergh, and there are tales of him flying in and landing on Cima del Mundo's meadows. Mrs. Knight apparently had a limitless bankroll, as she not only developed Cima del Mundo with an eye toward perfection, as exhibited in the superb stonework in this gatehouse, but also gained fame as the builder of Vikingsholm, the iconic stone castle on the shores of Lake Tahoe. Made of rounded stones of all sizes, with strong porch pillars, bordering walls, and cut stone steps, the gatehouse is a veritable symphony of stone. (Both, CONS.)

Behind the long wall bordering East Valley Road stands a set of stone barns which date back to the 1920s and 1930s and are still in heavy use housing horses, principally for the polo fields. They are classics of their kind, with stonework so fine as to almost defy description. One only wonders why those skilled masons settled for wooden window and door frames, for clearly they had the proficiency to fashion them of stone. Perhaps it was thought that a barn ought to have a rustic flavor and wood served that purpose. For lovers of stonework, these structures are mecca. (Both, CONS.)

Dating back to the days of horses and buggies (1910), this watering trough at the junction of Mission Canyon Road and Mountain Drive is a stunning example of the stonemason's art. Commissioned by G. S. J. Oliver in memory of her husband, the trough was carved from two large boulders, one weighing about 5,000 pounds, the other well over 10,000, by the expert English stonemason George Robson. (CONS.)

In the horse-drawn era of history, stone hitching posts were ubiquitous along Santa Barbara city streets. There are still a surprising number of them of all sorts and sizes gracing parkways as residents recognize them not only as relics of the past but also as interesting pieces in their own right. Here is a particularly well-cut and well-preserved post. (CONS.)

This extraordinary stone structure, made from stream rocks and heavily buttressed at the four corners, was built as a pump house to shelter a well on the Conklin Farm some time before the beginning of the 20th century. Its various owners have cherished the little place and kept it up beautifully. Note the wonderful details in the stonework over the door and window, indicative of a stoneworker who knew and loved his work. (CONS.)

Aware of the potential for flooding along the various creeks cutting their courses down from the hills, officials put stonemasons to work shaping and channeling those that posed the greatest threat. Here, on San Ysidro Creek, the channel is floored and walled with stone, and a small stand of trees in midstream is protected by a pointed stone revetment diverting water flow to either side. (CONS.)

One of the more curious manifestations of stone architecture in the Santa Barbara region was the so-called haunted chapel on the site of the proposed Naples Resort on the coast just west of Santa Barbara. In 1887, just as the boom of the 1880s in Southern California was turning to bust, John H. Williams and his wife, Alice Paist Williams, purchased a portion of the Dos Pueblos Ranch with the intention of developing a resort community, which they called Naples. Success was dependent on the completion of the Southern Pacific Railroad south from San Francisco to Santa Barbara. That did not occur at the time, because the oncoming depression in land prices caused the railroad to cease building well short of Naples. Williams died in 1895, and his wife later commissioned architect Francis W. Wilson to build a Gothic chapel to house his remains. The handsome structure was built in 1899 utilizing good, hard sandstone quarried in the nearby Santa Ynez Mountains and stood in stark contrast to its empty surroundings. (SBHM.)

Alice Williams hoped that it would become a wedding chapel, but the presence of her husband's remains and the caskets of her two pug dogs repelled people, so the building stood empty and unused for years. When the Southern Pacific finally completed its tracks to Santa Barbara, she had her husband's casket exhumed and put on the initial train to Santa Barbara to fulfill his earlier promise to ride the first train from Naples. The casket was immediately brought back and reinterred in the chapel. The community was relieved when the earthquake of 1925 badly damaged the building, and its removal eliminated what had become an attractive nuisance. The resort town has never been developed. (SBHM.)

As an indication of the size of some of the boulders that provided the raw materials for stone construction, here is an unidentified man on horseback in Mission Canyon next to a huge rock. The nearly magical hands of skilled masons could split and cut such a stone into usable blocks in a variety of shapes, sizes, and finishes. From such stones, and others even larger, came the pillars, lintels, and arches of Santa Barbara's major structures. (SBHM.)

Huge boulders still tower above hikers in Mission Canyon—this one is in the Santa Barbara Botanic Garden—and conceivably could still provide the raw materials for more building. After contemplating the miles of walls, the number of buildings, houses, bridges, and other stone fabrications in the Santa Barbara area, one can only marvel at what the landscape looked like before the stonework began. (CONS.)

This agglomeration of boulders at the entrance to Rocky Nook Park in Mission Canyon just beyond the Mission Creek Bridge offers a sense of the huge boulder fields that once marked the canyon, Mission Ridge, and much of the Santa Barbara region. No wonder Mission Canyon was a primary source of stone building materials. (CONS.)

The sandstones of Santa Barbara came in a variety of hardness, and the local geology occasionally produced stones with unusual colorations, sometimes called "picture rocks." Although such stones tended to be soft, from time to time, a whimsical stonemason would set one just to add distinctiveness to what he was doing. Certainly it is a conversation piece. (CONS.)

Mission Canyon, which still harbors an apparently unending supply of huge sandstone boulders, was a major source of raw materials for local construction projects. The upper photograph shows a small crew cutting and shaping stones on the ground in the canyon before loading them onto the wagon in the background for transport to job sites. The lower photograph features master mason Fred Moore (left), whose work still graces such prominent locations as the gates to the Santa Barbara Cemetery, preparing stone in Mission Canyon. The nameless photographer noted, rather superfluously, that all the stones were lifted by hand. Certainly extraordinary strength was a necessary attribute of those early masons. (Both, SBHM.)

During the heyday of stone construction, no edifice, however mundane, was exempt from the mason's art. Here is the incinerator at Casa del Herrero, an obviously difficult to build circular, domed structure bound with iron straps to hold it together during great extremes of heating and cooling. It still stands, a mute homage to its creators. (MHC.)

When city benefactor Dr. Charles Caldwell Park decided to memorialize his two sons who died prematurely, he commissioned architect Francis W. Wilson to create a fountain "for man and beast." A classic Beaux Arts design meticulously crafted out of stone, each of the seats ranging in a semicircle around the lion's head fountain are carved from a single boulder. The fountain is no longer connected to a water supply but remains a beautiful remembrance of the past. (CONS.)

Some of the earliest stonework in Santa Barbara was done by the Chumash people under the direction of the mission padres. Recognizing the Mediterranean climate that dominates the area, the padres realized the availability of water would be a problem for much of the year. The priests had the natives build a dam in Mission Canyon to provide a year-round source of the precious substance. While this dam does not demonstrate the classic stonework exhibited elsewhere in this book, it certainly has served its purpose. Though the reservoir is now well silted in behind the structure, it still stands and is a focal point for walkers in the Santa Barbara Botanic Garden. (Both, CONS.)

In addition to the dam, Chumash laborers, under the direction of the mission staff, also constructed a stone aqueduct that snaked down Mission Canyon and delivered water to a reservoir built on mission property. A portion of the aqueduct still exists in the Santa Barbara Botanic Garden and allows visitors another insight into the origins of the city. (CONS.)

This photograph of the mission reservoir system was taken in the late 1800s and shows the upper works already as ruins. The original stone-walled reservoir, with the black fence surrounding it, was still a working unit providing water to the city. Its original walls still form a 110-foot square holding 7 feet of water. The reservoir was later roofed and continued to be a part of the city water system into the 1980s. (SBHM.)

The upper reservoir of Mission Santa Barbara, built in conjunction with the gristmill in 1827, exhibits a more sophisticated stone building technique, reflecting the passage of time and the arrival in Alta California of more specialized residents and officials. The upper photograph is the common wall between the reservoir and gristmill, showing the hole at the base through which water was forced under pressure to turn the grinding apparatus. The walls were originally plastered. The lower photograph shows the interior of the gristmill, the holes in the wall indicating the placement of the heavy beams that supported the interior of the structure. While adobe construction is usually associated with early California, stone was essential for larger constructions and for manufacturing establishments. (Both, CONS.)

While the mission water system was crude by modern standards, it was quite sophisticated for its day, especially when a stone filter house was constructed on the hill above the reservoir to ensure potable drinking water for the residents. This stone structure still stands and forms a portion of Mission Historical Park near the mission. To visit is to take a trip back in time and to be astonished at the manufacturing capability of the mission. (SBHM.)

Among the interesting exhibits in Mission Historical Park is this aqueduct, again of stone, which wanders down the hill from the filter house to a spot where citizens could obtain good drinking and cooking water. It was essential to maintaining the health of the citizenry. (CONS.)

What do you do when your property is so littered with boulders that you don't know what to do with them? The old Ward Estate created a special garden section utilizing the entire variety of sizes and shapes, terracing them down a hillside and connecting some of them to water. (SBHM.)

The permanence of stone occasionally provides a reminder of the historical past, as in the case of the Weeping Willow Inn. Once a popular eatery operated by Guadalupe Cota in Spanishtown, the Weeping Willow Inn closed in 1933 upon Cota's death. The steps are all that remain. Noted mason Phil Henley, himself a resident of Spanishtown, cut the steps, as he had cut the lettering on the massive lintel on the Howard-Canfield building. (SBHM.)

"THE TIMBERS, near Santa Barbara, California."

In early 1942, the only known Japanese attack on the American mainland occurred just west of Santa Barbara. A lone submarine lobbed a few shells toward a minor oil field along the coast, damaging a pier and its catwalk but causing no loss of life or any serious damage. Heavy timber salvaged from the stricken wharf was used to construct the Timbers restaurant just above the attack site. The Timbers also features this massive river-stone fireplace, which has kept innumerable diners warm on cold, wet, winter nights over the years. The stones, mined from nearby Winchester Canyon, were laid up with defiant joy by the masons involved, and the building still reminds patrons of those long-ago days. (Both, SBHM.)

BIBLIOGRAPHY

Andree, Herb, Noel Young, and Patricia Halloran. *Santa Barbara Architecture, From Spanish Colonial to Modern.* 3rd ed. Robert Easton and Wayne McCall, eds. Santa Barbara: Capra Press, 1995.
Beresford, Hattie. "The Way It Was: I. G. Waterman and Mira Vista." *Montecito Journal* (March 2008): 27–29.
Brubeck, Dorothy W. *A Salute to 100 Years: Santa Barbara High School, 1875–1975.* Santa Barbara: Santa Barbara High School, 1975.
Cleek, Patricia Gardner. "Santa Barbara Stonemasonry." *Noticias* 40, no. 1 (Spring 1994): 1–24.
Conard, Rebecca and Christopher H. Nelson. *Santa Barbara: A Guide To El Pueblo Viejo.* Santa Barbara: Capra Press, 1986.
Gebhard, Patricia and Katherine Masson. *The Santa Barbara County Courthouse.* Santa Barbara: Daniel and Daniel, 2001.
Griscom, Elane. "Stone Masons: Montecito's 'Old World' Artisans." *Montecito Magazine* 8 (Spring 1998): 28ff.
Hadingham, Evan. "Unlocking Mysteries of the Parthenon." *Smithsonian* 38, no. 11 (February 2008): 36–43.
Stephen Mikesell. *Historic Highway Bridges of California.* Sacramento, CA: California Department of Transportation, 1990.
Ishkanian, Dr. Judith. "Montecito Diary: Every Stone Can Tell a Story of Italian Craftsmanship." *Santa Barbara News-Press,* May 27, 2004.
Kirker, Harold. *California's Architectural Frontier.* San Marino, CA: Huntington Library, 1960.
Myrick, David F. *Montecito and Santa Barbara.* 2 Vols. Glendale, CA: Trans-Anglo Books, 1987, 1991.
Penfield, Wallace O. "Santa Barbara County Bowl: Some Recollections." *Noticias* 19, no. 1 (Spring 1973): 1-10.
Petry, David. *The Best Last Place: A History of the Santa Barbara Cemetery.* Santa Barbara: Olympus Press, 2006.
Tompkins, Walker A. *The Riviera.* Santa Barbara: Santa Barbara Board of Realtors, 1978.
———. *Santa Barbara History Makers.* Santa Barbara: McNally and Loftin, 1983.

The Santa Barbara Conservancy

The Santa Barbara Conservancy was formed a decade or so ago by the late John Pitman, F.A.I.A. His purpose was to bring together the wide array of individuals, public agencies, and other groups concerned with issues that fell under the broad rubric of historic preservation. Envisioning the organization as one that would serve as an information exchange, a sounding board for ideas and actions, a forum for open and frank discussion of issues, and a facilitator of communications among the various members, John further saw the Santa Barbara Conservancy as a way to focus the attention of public policy-making agencies and proactive private organizations on the most critical issues that could have an impact on Santa Barbara's quality of life. As the organization has evolved, the Santa Barbara Conservancy has expanded its mission to include educating the general public on historic preservation, and documenting Santa Barbara's wonderful historic resources, hence this publication and others to follow.

The Santa Barbara Conservancy is a nonprofit organization capable of raising the funds necessary to enable its activities. It can be contacted through its Web site: sbconservancy.com.

DISCOVER THOUSANDS OF LOCAL HISTORY BOOKS
FEATURING MILLIONS OF VINTAGE IMAGES

Arcadia Publishing, the leading local history publisher in the United States, is committed to making history accessible and meaningful through publishing books that celebrate and preserve the heritage of America's people and places.

Find more books like this at
www.arcadiapublishing.com

Search for your hometown history, your old stomping grounds, and even your favorite sports team.

Consistent with our mission to preserve history on a local level, this book was printed in South Carolina on American-made paper and manufactured entirely in the United States. Products carrying the accredited Forest Stewardship Council (FSC) label are printed on 100 percent FSC-certified paper.

MADE IN THE USA